Philadelphia

IMPRESSIONS

Photography by Richard Nowitz

FARCOUNTRY
PRESS

Right: The financial district rises beyond Fairmount Water Works Interpretive Center *(bottom left)* and the Schuylkill River.

Below: In Center City Philadelphia, Phlash trackless trolleys deliver riders to nineteen key locations, including train stations, a ferry depot, and visitor destinations.

Title page: Visitors and residents alike marvel at the drama of Alexander Calder's Swann Memorial Fountain at Logan Square.
PHOTO BY ABRAHAM NOWITZ

Front cover: Logan Square, at one end of the Benjamin Franklin Parkway, glows at twilight.
PHOTO BY ABRAHAM NOWITZ

Back cover: The City Hall clock tower is one of the most recognizable features of the Philadelphia skyline.

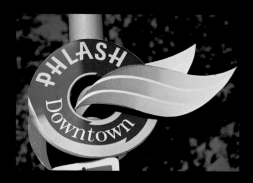

ISBN 10: 1-56037-417-9
ISBN 13: 978-1-56037-417-6
© 2007 by Farcountry Press
Photography © 2007 by Richard Nowitz

All rights reserved. This book may not be reproduced in whole or in part by any means (with the exception of short quotes for the purpose of review) without the permission of the publisher.

For more information about our books, write Farcountry Press, P.O. Box 5630, Helena, MT 59604; call (800) 821-3874; or visit www.farcountrypress.com.

Created, produced, and designed in the United States.
Printed in China.

12 11 10 09 08 07 1 2 3 4 5 6

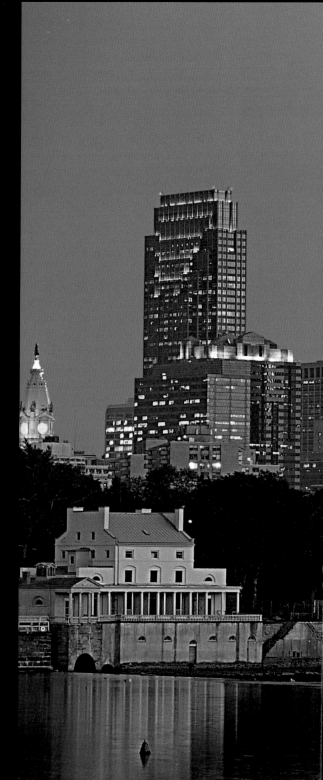

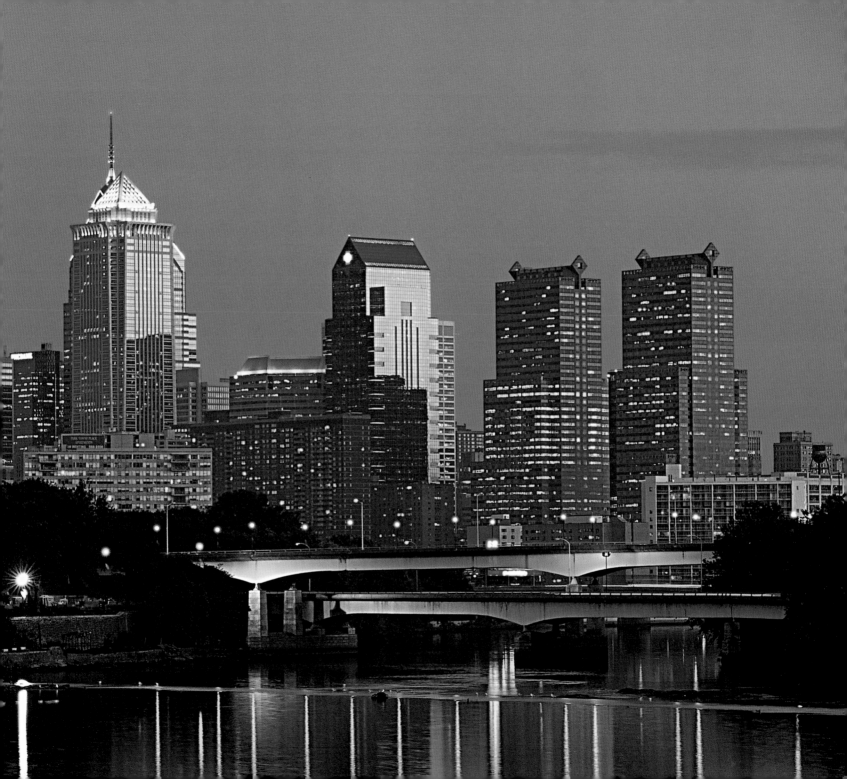

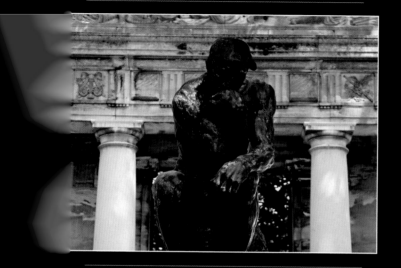

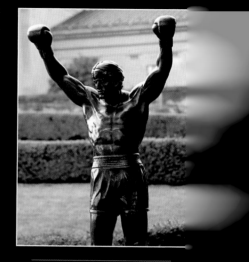

by Matt Nesvisky

Above: Auguste Rodin first sculpted a small plaster version of his most famous work *The Thinker* in 1880. The first heroic-sized bronze casting went on exhibit in Paris twenty-four years later. Today more than twenty such castings are on exhibit around the world, including this one at Philadelphia's Rodin Museum.
PHOTO BY ABRAHAM NOWITZ

Above right: Created as a film prop for *Rocky III*, this eight-foot-tall statue of fictional boxer Rocky Balboa stood atop the Philadelphia Museum of Art's stairs from 1982 until 2006, when it was moved to ground level. The museum board's narrow decision to accept the sculpture permanently has been both praised and panned in Philadelphia and the American arts community.

He says it's impossible for him to name a favorite. But he does have a special place in his heart for Philadelphia, and the evidence of that love affair is between the covers of the book you are now holding.

The reason for Richard's attraction to Philadelphia seems obvious to me. Ever since it served as this nation's first capital, Philadelphia has remained one of those quintessential American cities. Philly, or as the natives further (and affectionately) conflate the name, Phlafya, has it all: Colonial history and cutting-edge modernity; fox-hunting estates and inner city neighborhoods crying for rehabilitation; the elegant Boathouse Row and row upon row of brick-and-shingle rowhouses; an Ivy League campus and a (more or less) Major League Baseball team; a world-class symphony orchestra and sidewalk doo-wop; factories and theaters that inhabit former factories; fine arts, fine dining, and fines for all those places where you foolishly thought it was legal to park.

As with any American city that has long served as a major port, Billy Penn's little disembarkation point on the Delaware River today is as varied as it gets: Quakers and Koreans, Vietnamese and Hispanics, Greeks and Turks, Germans and Swedes, African Americans, and African Africans. We have kosher delicatessens, Irish pubs, and sushi by the yard. We also have Chinatown and the biggest and liveliest Italian outdoor market this side of Sicily. But while Philadelphia is decidedly a city of neighborhoods, it is no agglomeration of enclaves. We

tween the banks of the Delaware and Schuylkill rivers, the City of Brotherly Love believes in mix 'n match—always has, always will.

Some places simply lack character. Philadelphia is nothing but character. Just a few blocks from Independence Hall, for example, is Elphreth's Alley, the oldest continually inhabited residential street in America. The operative term here is continually inhabited. Philadelphia doesn't hide its history in museums. History is part and parcel of our everyday lives.

All of this means Philadelphia is nothing if not photogenic. That's why, for the past decade or so, Richard Nowitz has made yearly pilgrimages to Phlafya. Because the city is compact and largely flat, Richard can indulge his favorite means of shooting a city: from the seat of his bicycle. Richard's frequent biking buddy is his son Abe, who has contributed a few of his own photos to the pages that follow.

"I always bring my bike to Philly," Richard says. "I can scoot around town, pedal the byways and historic lanes, and just stop short and shoot whatever strikes my eye. And there's so much in this city—the amazing murals, the colonial architecture, the sidewalk markets, the astounding abundance of public art, the gorgeous city squares and parks. You've got the kind of public fountains you normally see only in Europe. I love the actual texture of this city—the

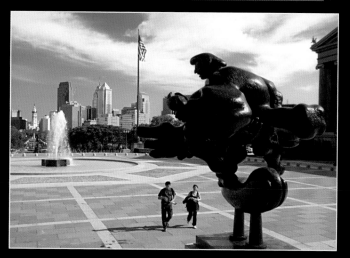

Standing on the Philadelphia Museum of Art's steps, you can see all the way down Benjamin Franklin Parkway to City Hall. The parkway was built fifty-some years after the museum's 1876 founding.

work. Of course there's also the endless variety And all of it's illuminated by a very special light, th light that would glad heart of any photogra

When he's not p the pavement, Ric likely to be found or top—any rooftop, higher the better. counts for some of th taking wide-angle a zoom shots in *Phil Impressions.* But don savor the quieter imp Richard has capturec often raucous metrop shadows in the founta special sparkle in a st river, the interplay in the classical colur public building, the e of a suspension bric austere beauty of the where Washington, Je and Franklin worship

Philly is a dream of a city for a photographer—a not? There's always been something dreamy about t For one thing, the dream of fraternal amity is embe the city's very name. Small wonder then that this i the Founding Fathers dreamed up the ideals that our nation. And hey, what other city erects a statue i of a hero dreamed up in Hollywood? New York Harl have Lady Liberty, but Philadelphia has Rocky Balb

For all these reasons and more, Philadelphia is America's great cities. Richard Nowitz likewise of America's great photographers. To my mind a that's a marriage made in digital heaven. See fo

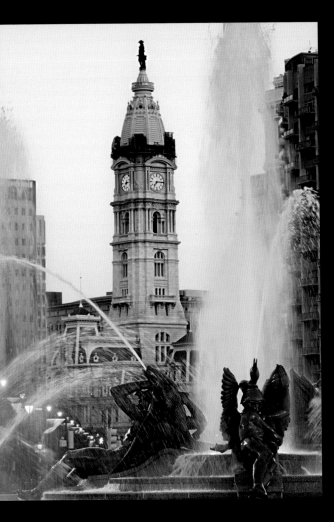

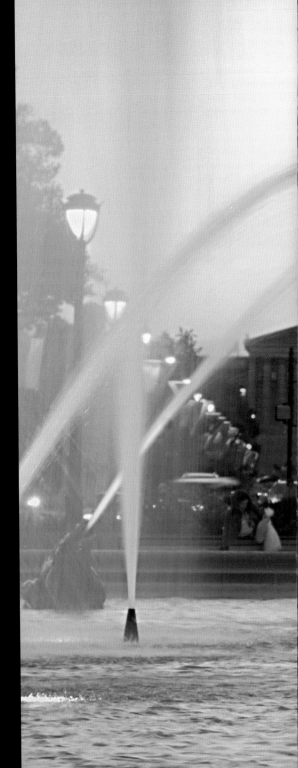

Above: The view across Swann Memorial Fountain in Logan Square includes the spire of Philadelphia City Hall.

Right: Dating from 1924, Swann Memorial Fountain honors Dr. Wilson Cary Swann, founder of the Philadelphia Fountain Society. Playing on the doctor's name, two swans are featured, and frogs, turtles, and a fish also spout water toward the center. Three reclining Native American figures represent the city's waterways: the Schuylkill and Delaware rivers and Wissahickon Creek.

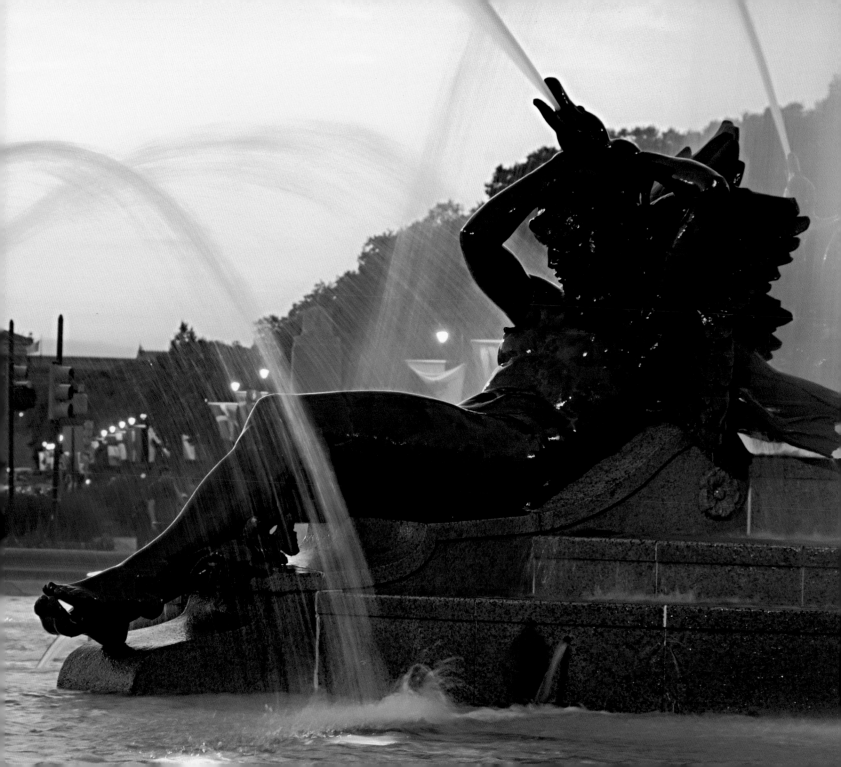

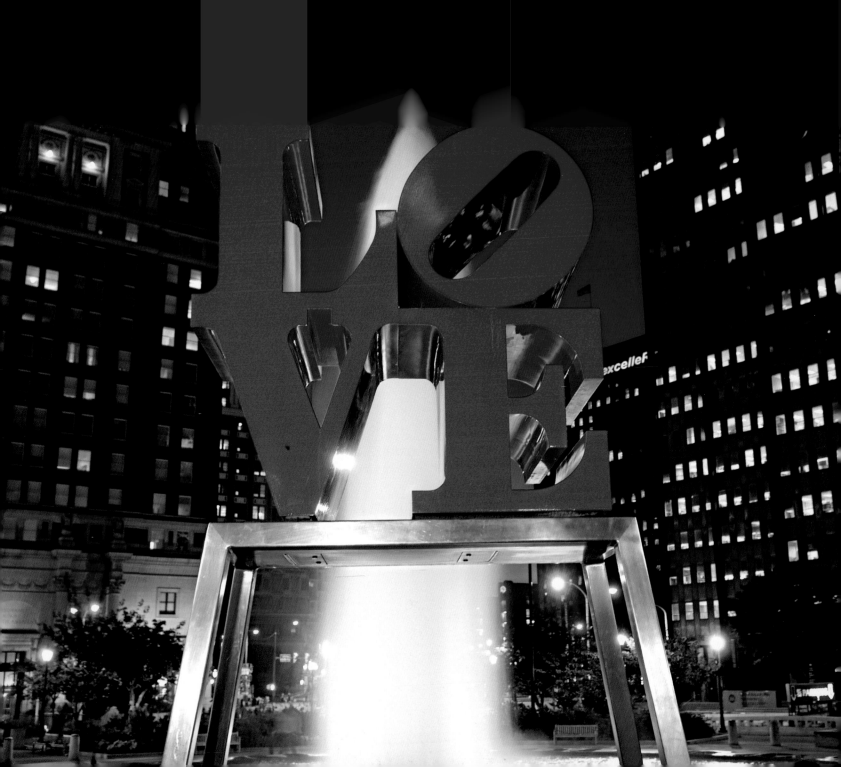

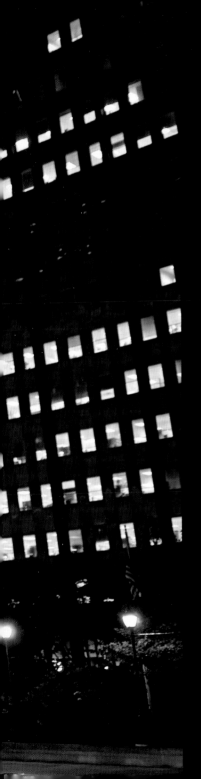

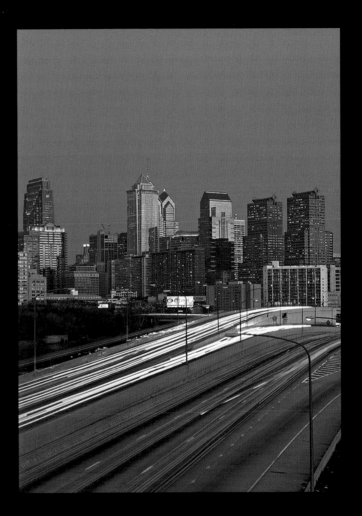

Above: One of Center City's major arteries throbs with homeward-bound traffic at the end of the business day.

Left: Founded by Quakers as the City of Brotherly Love, Philadelphia was 294 years old when sculptor Robert Indiana created the popular *Love* sculpture in John F. Kennedy Plaza in 1976.

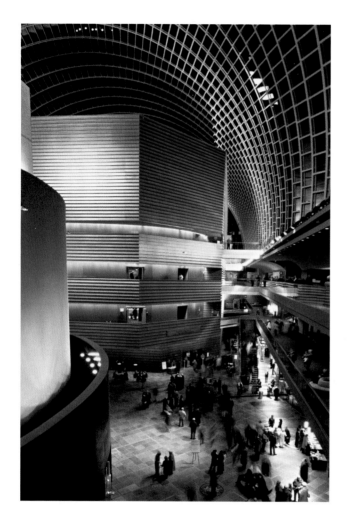

Above: Completed in 2001, the Kimmel Center for the Performing Arts offers marvelous acoustics and facilities to eight resident companies, including the Philadelphia Orchestra and other orchestras, opera and dance companies, and a children's theater.

Right: Boathouse Row's Victorian-era boathouses form the headquarters for Philadelphia's rowing community.

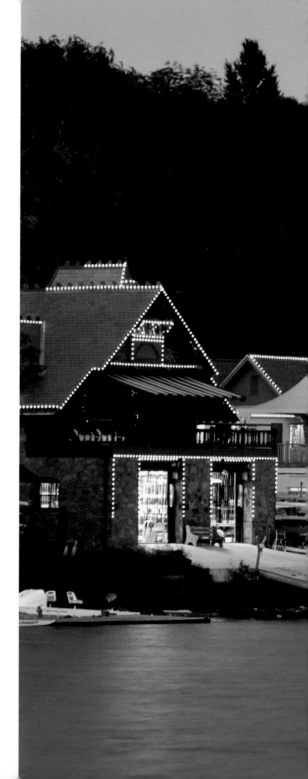

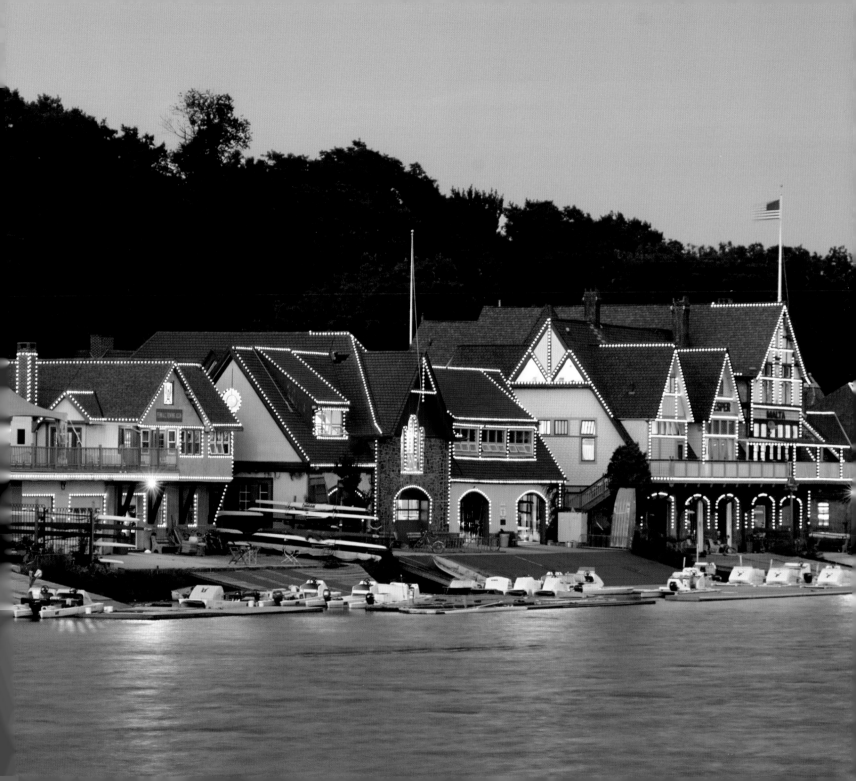

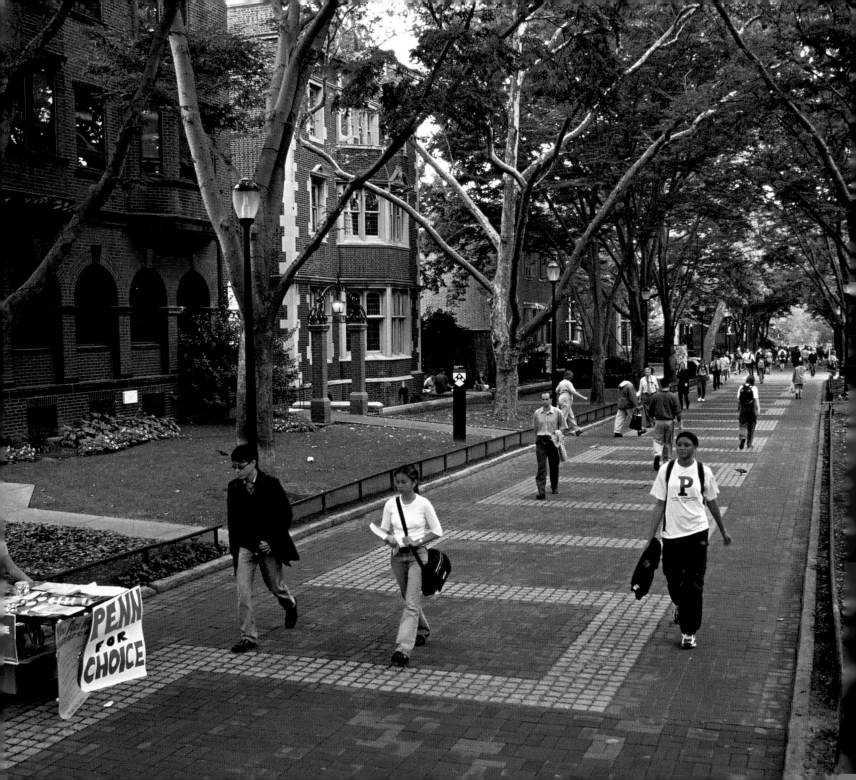

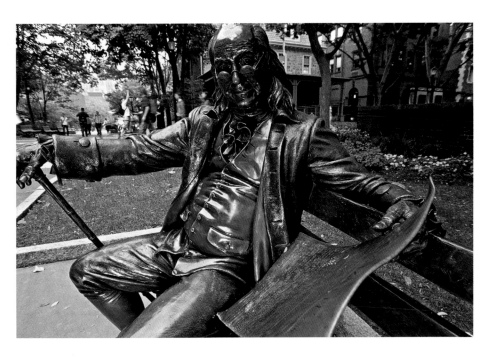

Above: Benjamin Franklin (1706–1790), one-time printer's "devil" (apprentice) and publisher of *Poor Richard's Almanac,* casually reads the newspaper in a 1987 sculpture by George Lundeen. Ben's bench is on the University of Pennsylvania's Locust Walk.

Left: Locust Walk, the university's main thoroughfare, is also a place for students to promote causes and concerns. The Ivy League, private university was founded in 1740.

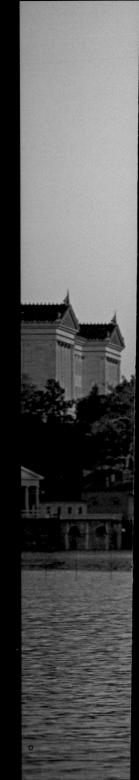

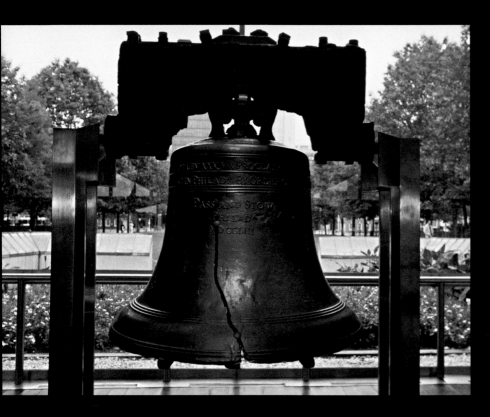

Above: Independence National Historical Park in Center City Philadelphia includes the Liberty Bell, Independence Hall, and other historical sites from the 1700s. The 2,000-pound bell, cast in 1753 from a Pennsylvania State House bell that had cracked, developed its own crack in 1846, was repaired, but cracked again.

Right: Scullers pause on the Schuylkill River for a bit of strategizing.

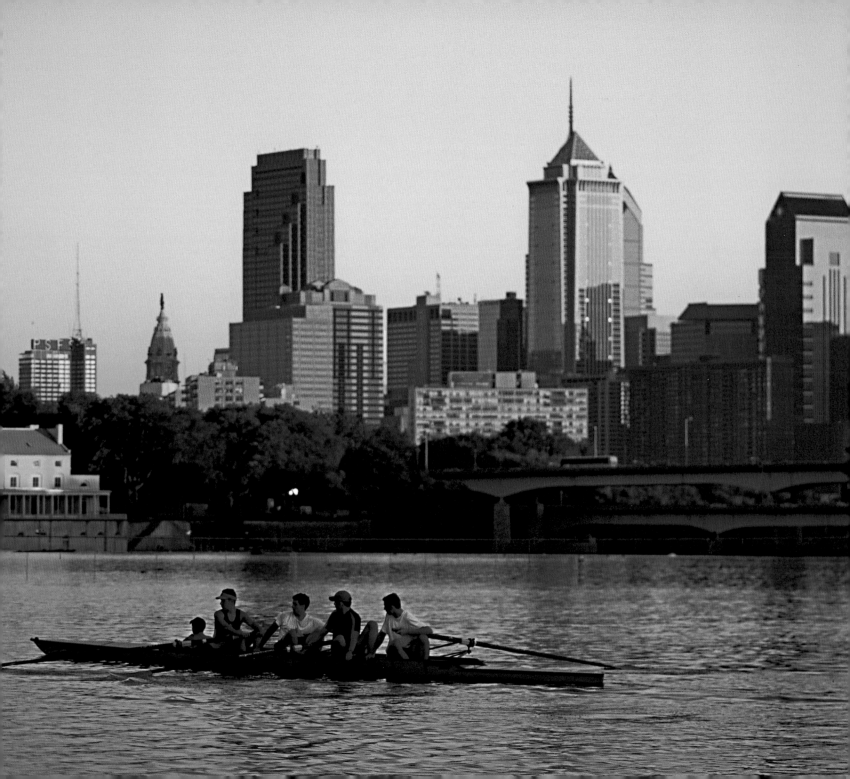

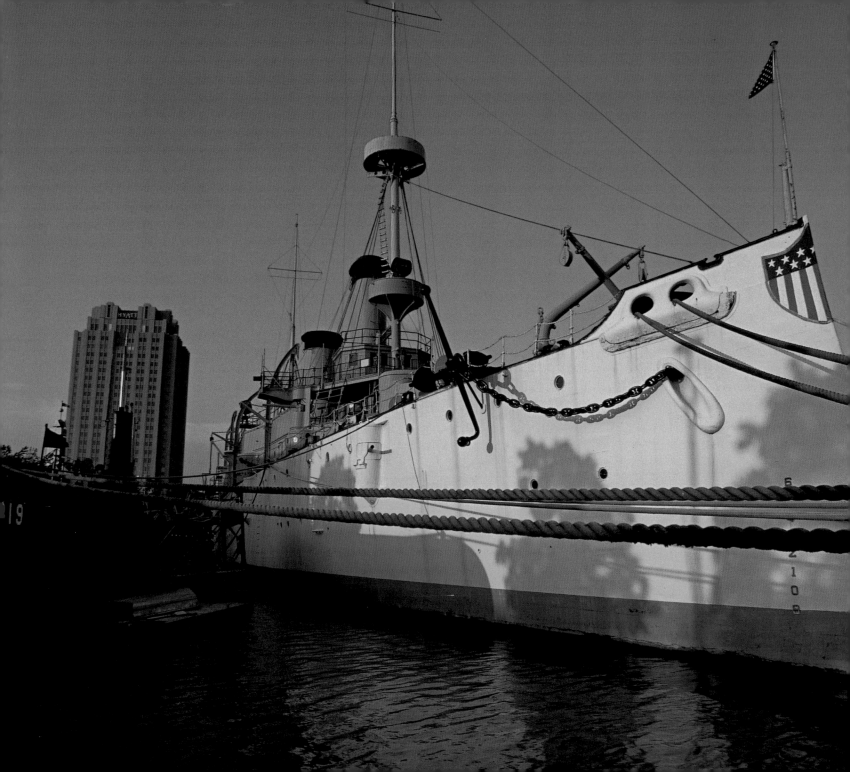

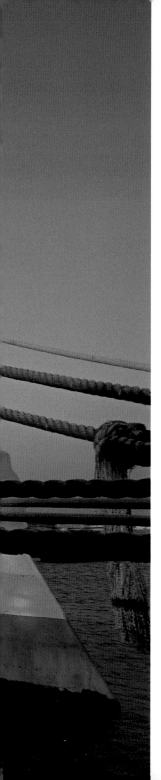

Left: At Penn's Landing, the U.S.S. *Olympia* forms part of Independence Seaport Museum and is the oldest steel warship still afloat in the world. It was built here six years before serving as Commodore George Dewey's flagship in the 1898 battle of Manila Bay in the Philippines during the Spanish-American War. After serving as a North Atlantic escort ship during World War I, *Olympia* was decommissioned in 1922.

Below: The area where William Penn disembarked from the ship *Welcome* in 1682 to found Philadelphia quickly became a busy harbor. Beginning in 1967, the city created Penn's Landing there, replacing old docks with a ten-block-long park that includes walking paths, an amphitheater, and a sculpture garden.

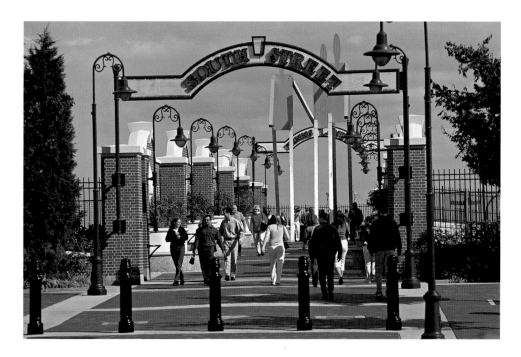

Right: This driver is one of many who offer horse-drawn carriage tours of the city.
PHOTO BY ABRAHAM NOWITZ

Below: The Society Hill neighborhood takes its name from Philadelphia's founding Quakers, formally known as the Society of Friends. Eighteenth- and early nineteenth-century buildings fill the district.

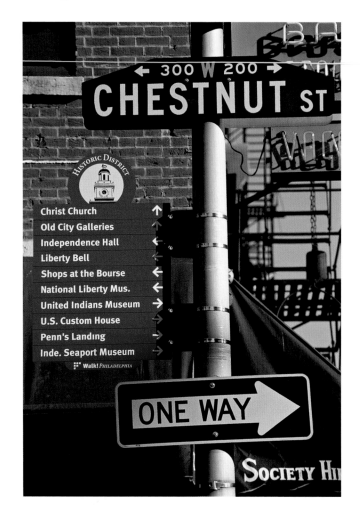

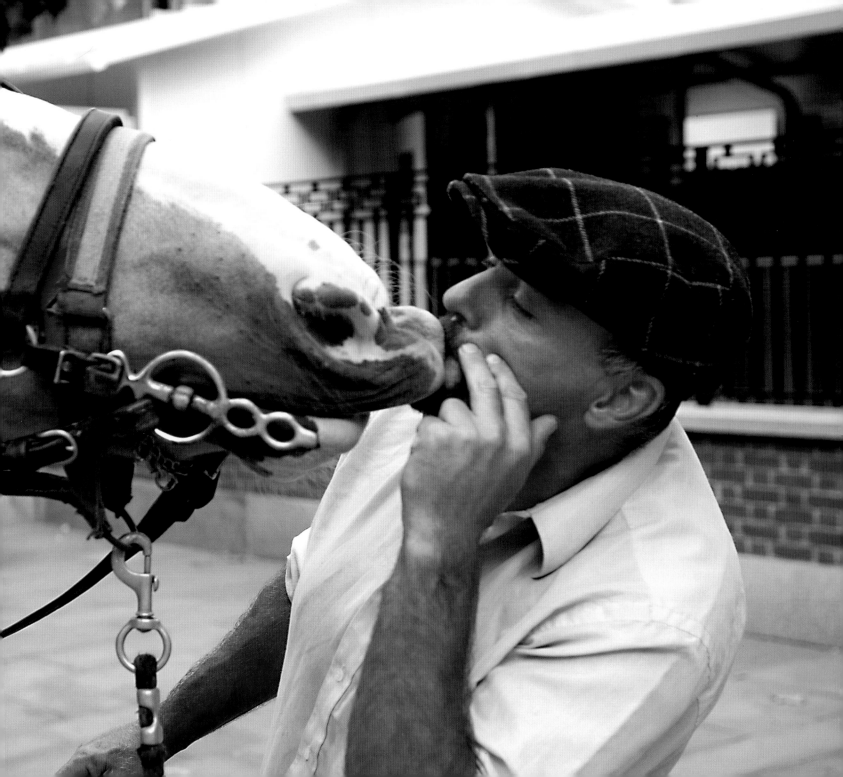

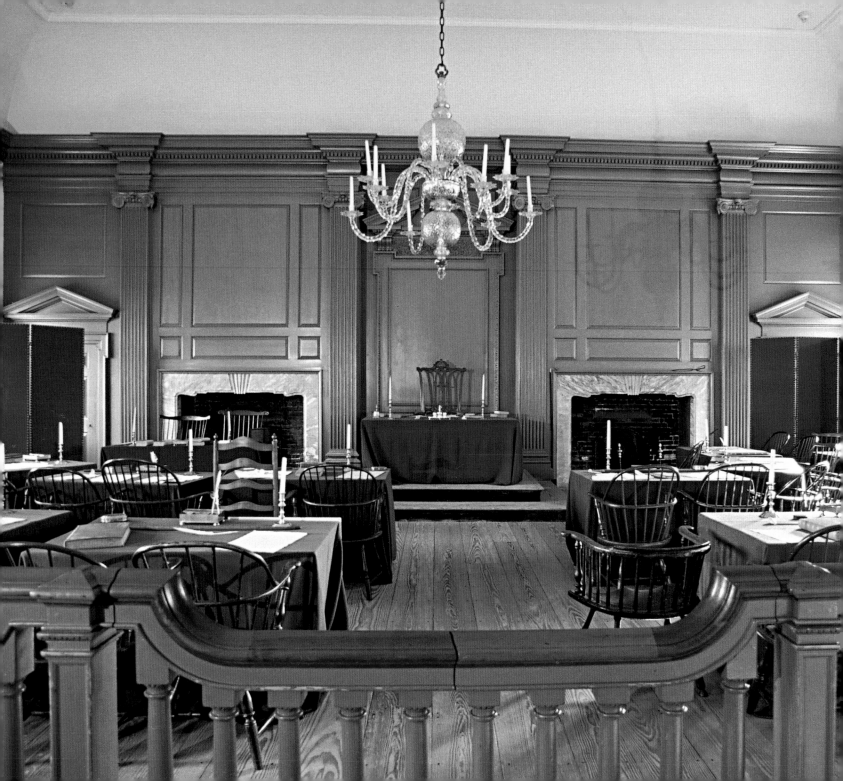

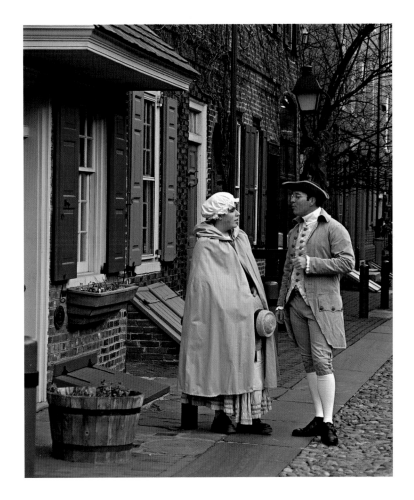

Above: Dating from the mid-1700s, Elfreth's Alley is America's oldest continuously inhabited street, with thirty-some residences scattered among art galleries, coffeehouses, and restaurants.

Left: Constructed from 1732 to 1756, Pennsylvania Colony's State House was where the Continental Congress met from 1775 to 1783—moving out during the winter of 1777 to 1778 when the British occupied the city. Here the Articles of Confederation were adopted (1781), and the U.S. Constitution was drafted (1787). Today, it's known as Independence Hall, and guided tours are offered in nine languages.

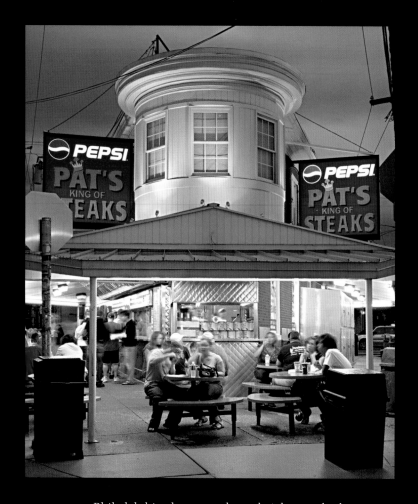

Above and right: Philadelphia cheese steak sandwiches—whether you buy them from Pat's King of Steaks, Geno's Steaks, or the dozens of neighborhood shops—include a long roll, chopped beef, mild cheese, and the option of fried onions. Invented in 1930, they've been adopted around the U.S.

Following pages: Because of the Fairmount Water Works dam, part of the Schuylkill River runs gently, making it a great place for sculling—a type of rowing in which each rower uses two oars.

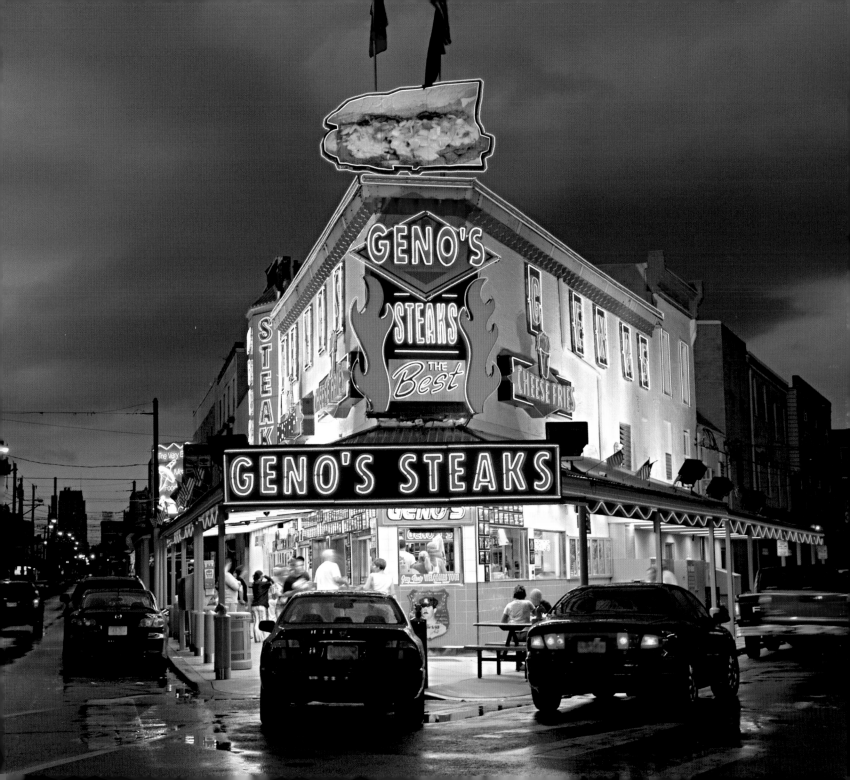

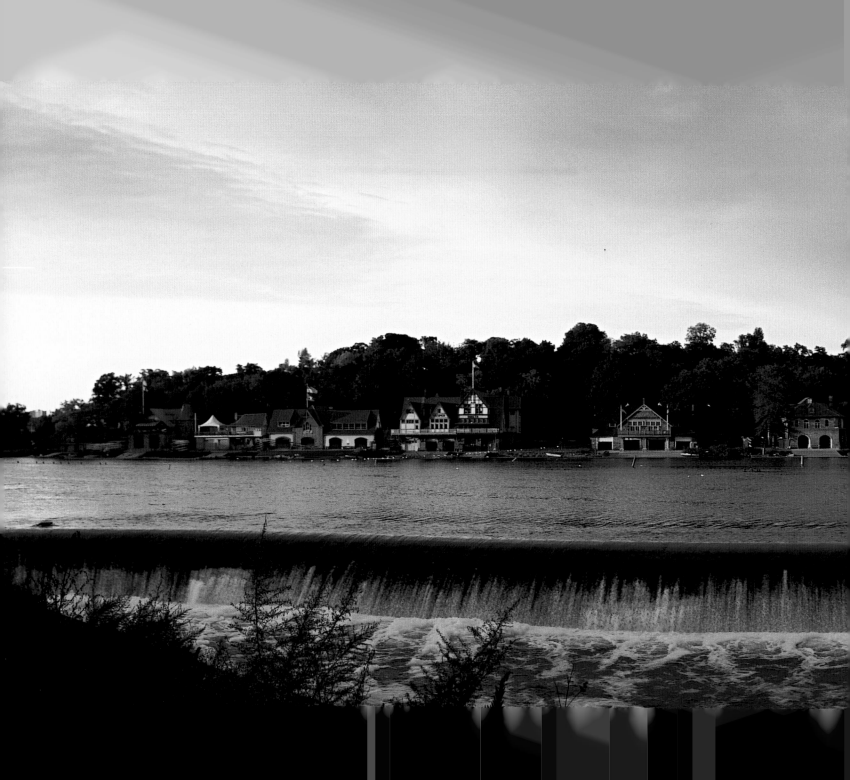

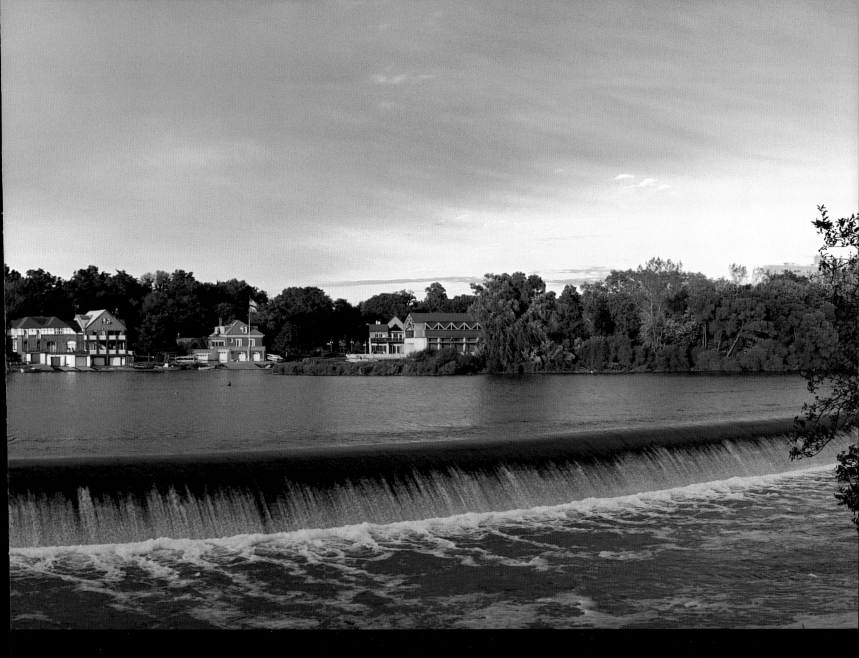

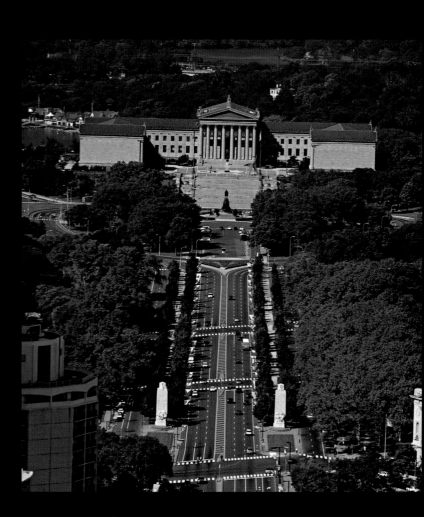

Above: From the observation deck just under the William Penn statue atop Philadelphia City Hall, this view is down the mile-long Benjamin Franklin Parkway to its terminus at the Philadelphia Museum of Art.

Left: More than 200 sculptures adorn Fairmount Park, including this one along the bike path. Outdoor art has been featured here since Fairmount Park Water Works opened in the first half of the nineteenth century.

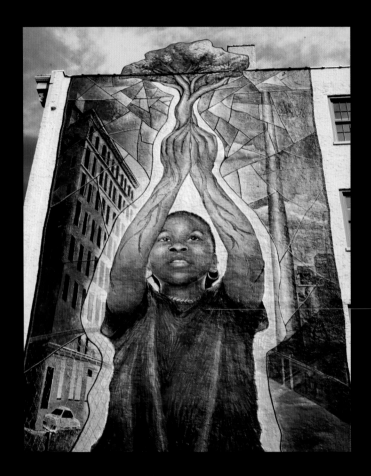

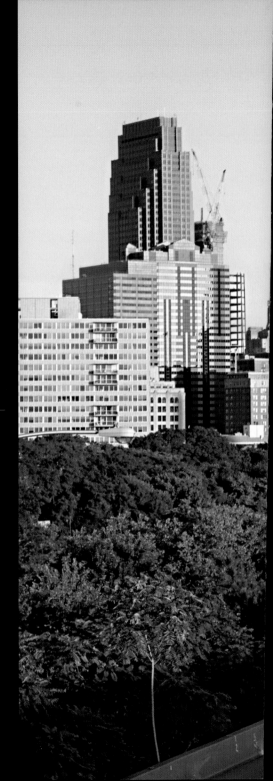

Above: Philadelphia buildings sport a multitude of murals.
This one by Josh Sarantitis, at 1926 Arch Street, is titled
Reach High and You Will Go Far.

Right: Interstate 676 takes drivers past Philadelphia's
business district.

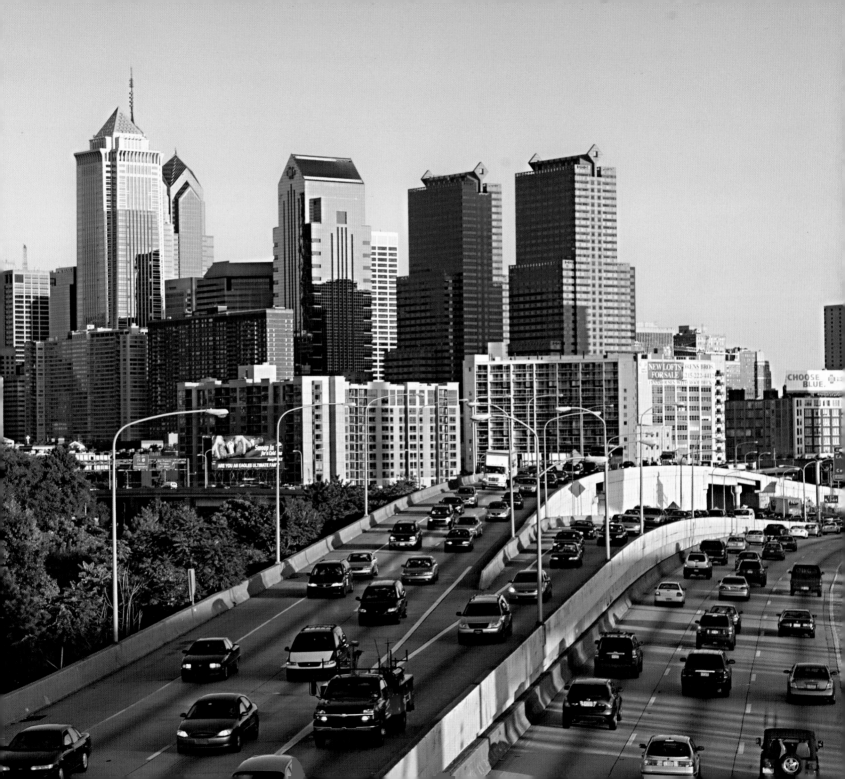

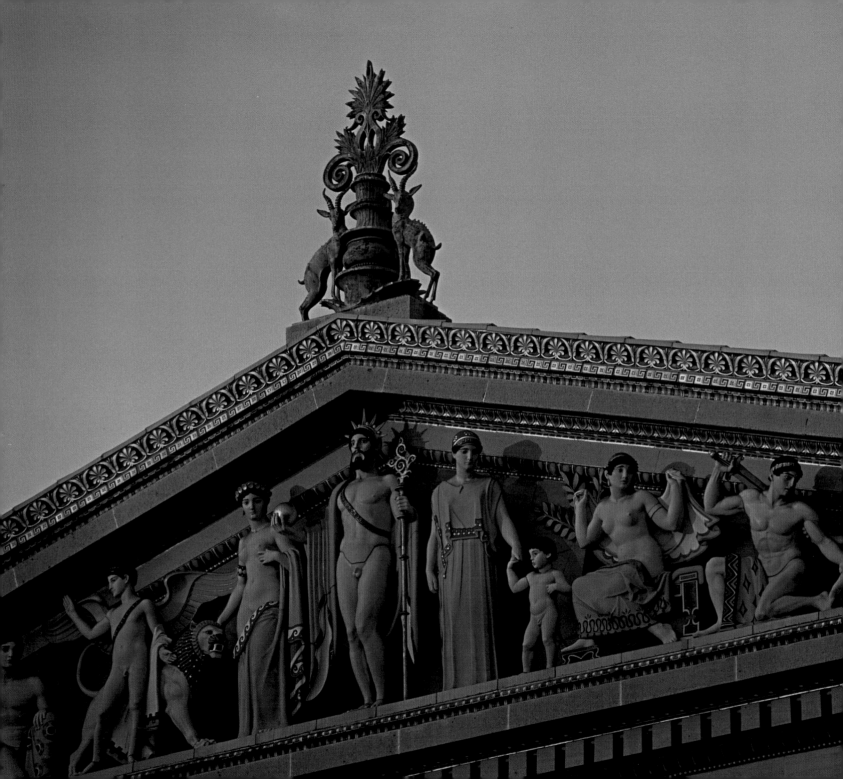

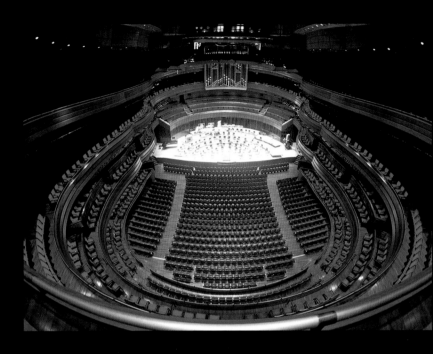

Above: Verizon Hall in the Kimmel Center for the Performing Arts seats 2,500 people for concerts and other performances.

Left: The Philadelphia Museum of Art's north pediment features neo-classical sculpture that is painted in the style of original Greek and Roman marbles.

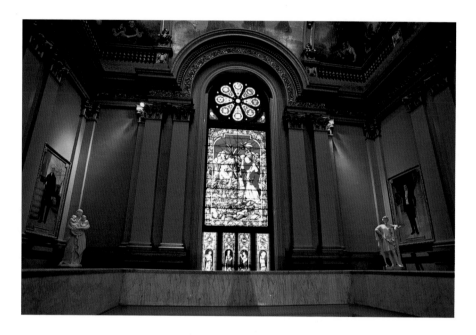

Above: Stained glass above the Grand Staircase of the Masonic Temple highlights the rich detailing of the building's interior. Completed in 1873 across from City Hall, the building is headquarters of Pennsylvania's Freemasons and is open for guided tours.

Right: Through the 1700s, Washington Square was a burial ground that included family plots and a potter's field. Later, mass graves of the Revolutionary War soldiers and victims of the city's 1793 yellow fever epidemic were added. This Tomb of the Unknown Soldier, placed behind a statue of George Washington (his face turned toward Independence Hall), was erected in the 1950s after an archaeological investigation of the site. It holds the remains of a twenty-year-old man whose skull indicates he died from a musket ball.

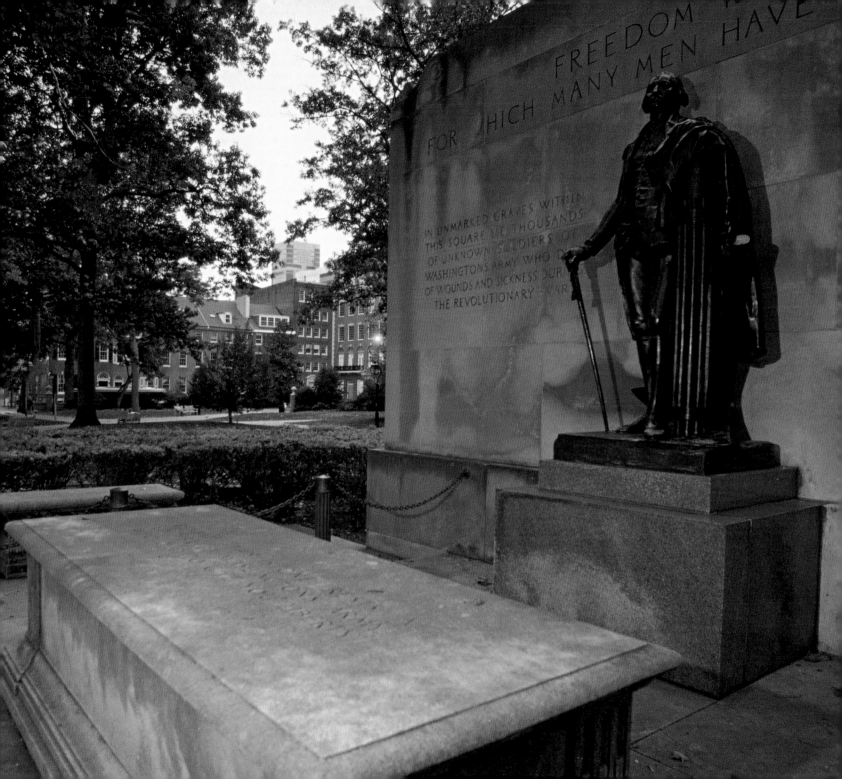

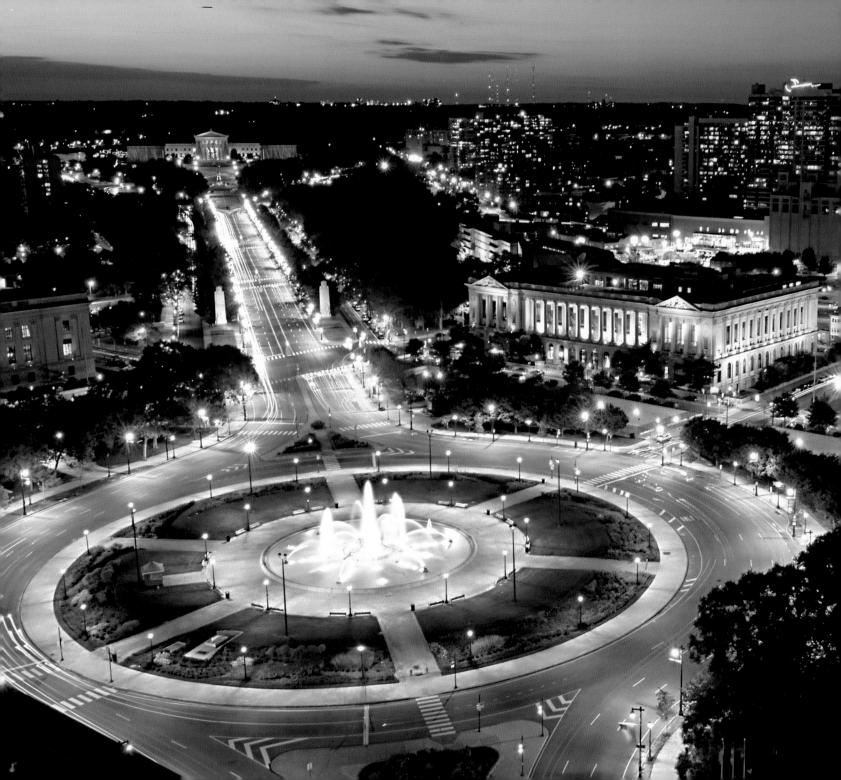

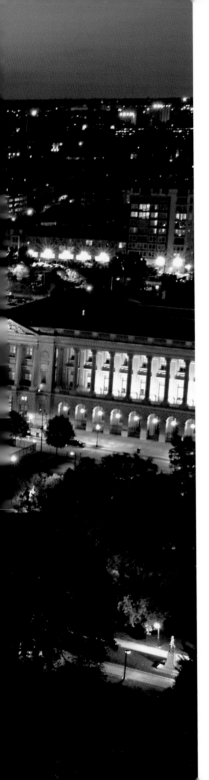

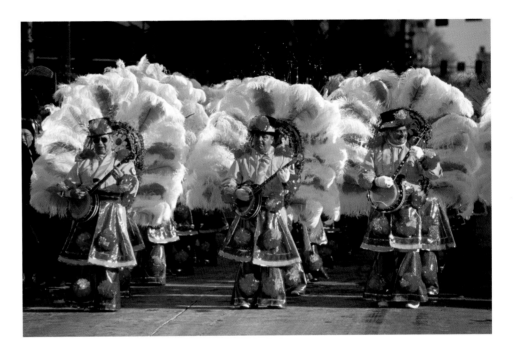

Above: Regardless of the weather, and almost every New Year's Day, Philadelphia's Mummers Parade features approximately 15,000 male marchers in elaborate costumes, and comic marchers who satirize current events. Drawing on ancient Roman tradition, this parade was initiated in 1901, skipping one year during World War I, as well as 1934, when the Great Depression meant that no prize money was available.

PHOTO BY BOB KRIST

Left: When William Penn mapped out Philadelphia, he labeled this site Northwest Square. Before becoming a park, it was the city's public execution site and a burial ground. In 1825 it was renamed Logan Square after Philadelphia statesman James Logan; it became round in the 1930s when Benjamin Franklin Parkway and the Swann Memorial Fountain were built.

PHOTO BY ABRAHAM NOWITZ

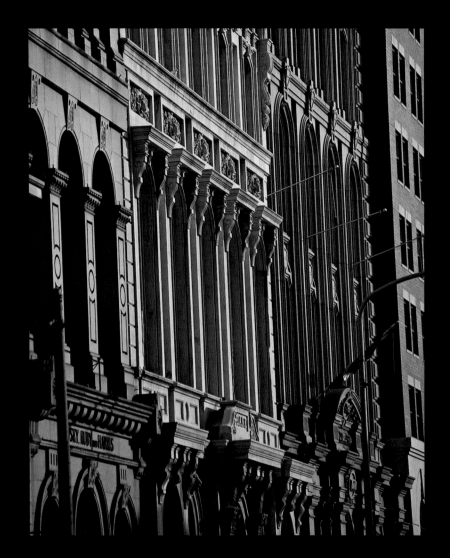

Above: Historical-architecture buffs find endless treats throughout Philadelphia.

Right: In the luxurious Ritz-Carlton Hotel, the Rotunda offers tea, cocktails, and light meals—with a chocolate buffet on weekends.

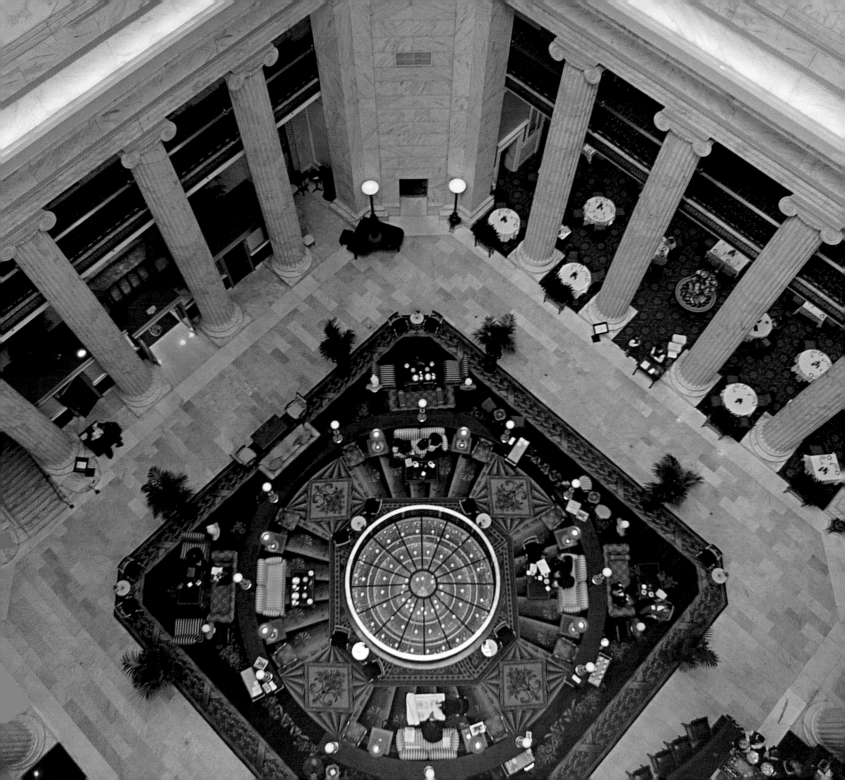

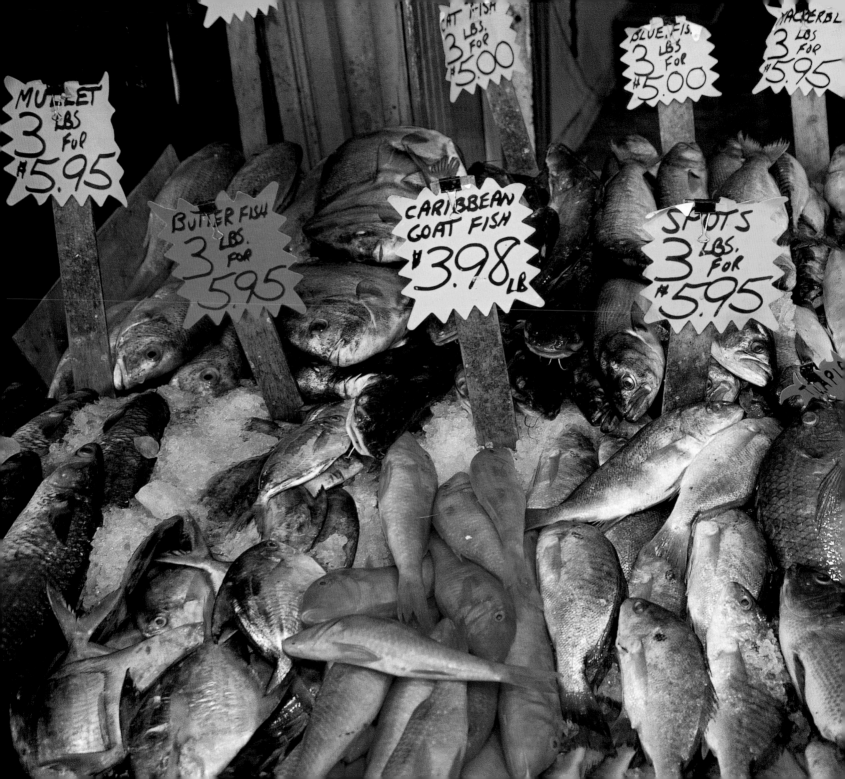

Above: Exuberant, bohemian South Street was an early rock hub in the 1960s, with live music at many bars and clubs. Today, it includes boutiques, chain stores, and tourist shops and continues to offer music in the late hours.

Left: The oldest and largest outdoor market in the United States is the Philadelphia Italian Market on Ninth Street. Fish, poultry, cheeses, baked goods, produce, clothing, and other dry goods are offered, and shoppers can pause for hoagies, cheese steaks, soft pretzels, cappuccino, and Italian, French, or Spanish cuisine.

Following pages: The United States' first world fair was the Centennial Exposition of 1876, held in Fairmount Park on the Schuylkill River.

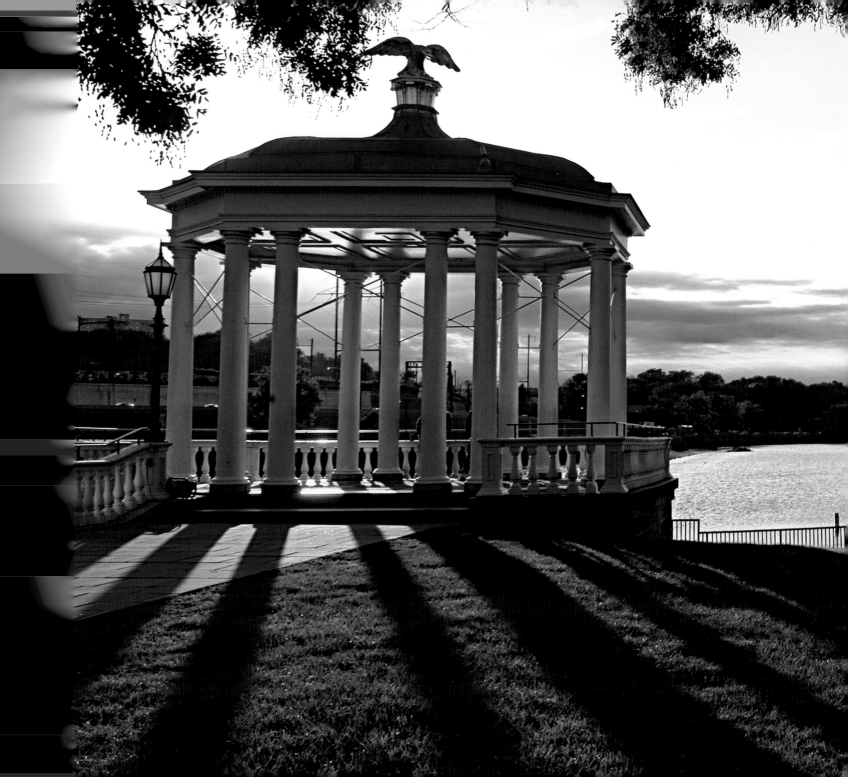

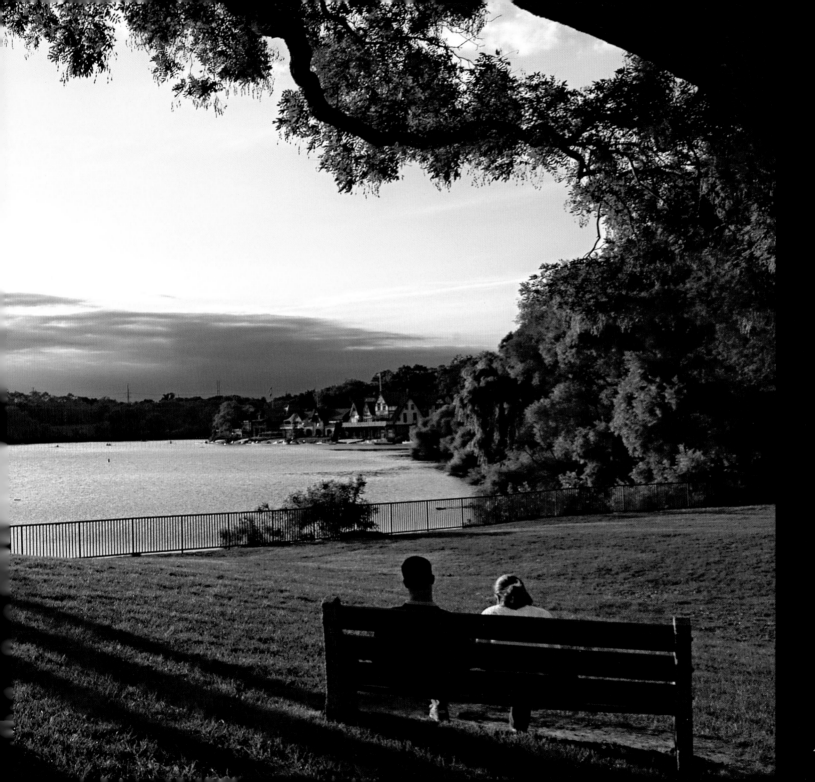

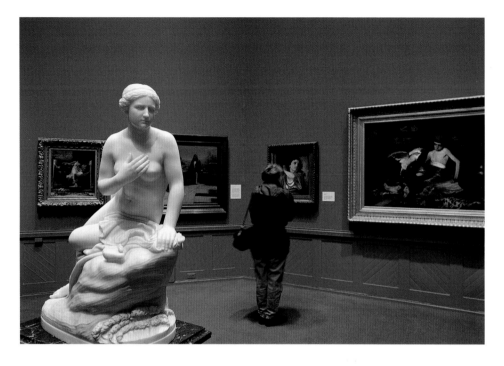

Above: The Pennsylvania Academy of the Fine Arts, dating from 1805, is the oldest art museum and school in the United States.

Right: Christ Church, an active Episcopal church, dates from 1727, but its congregation was founded in 1695. It has been called "the nation's church" because some of its worshippers included George Washington, Benjamin Franklin, Robert Morris, Francis Hopkinson, and Betsy Ross.

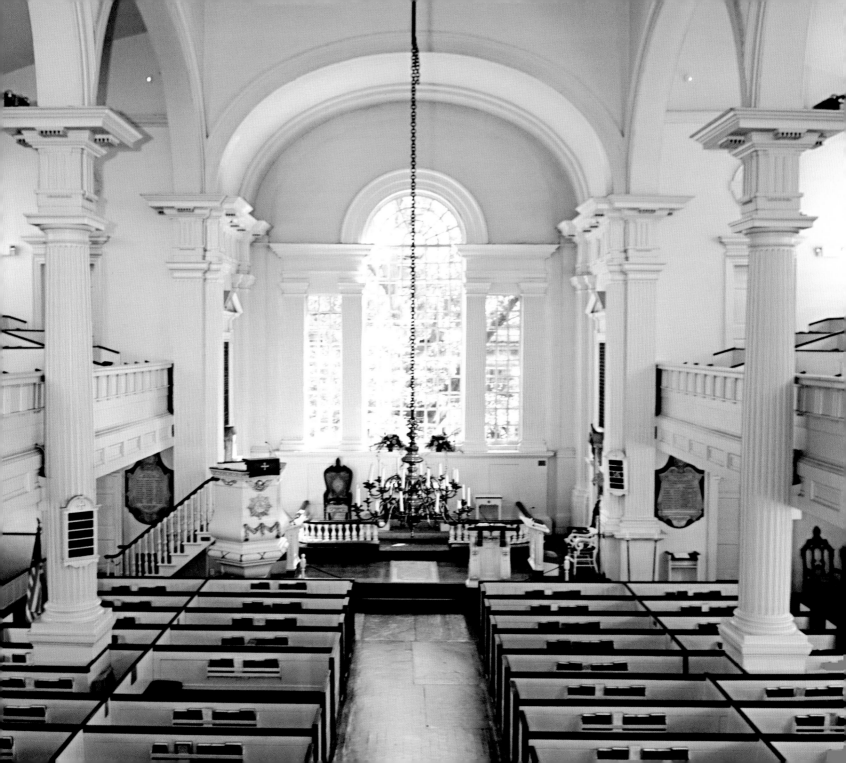

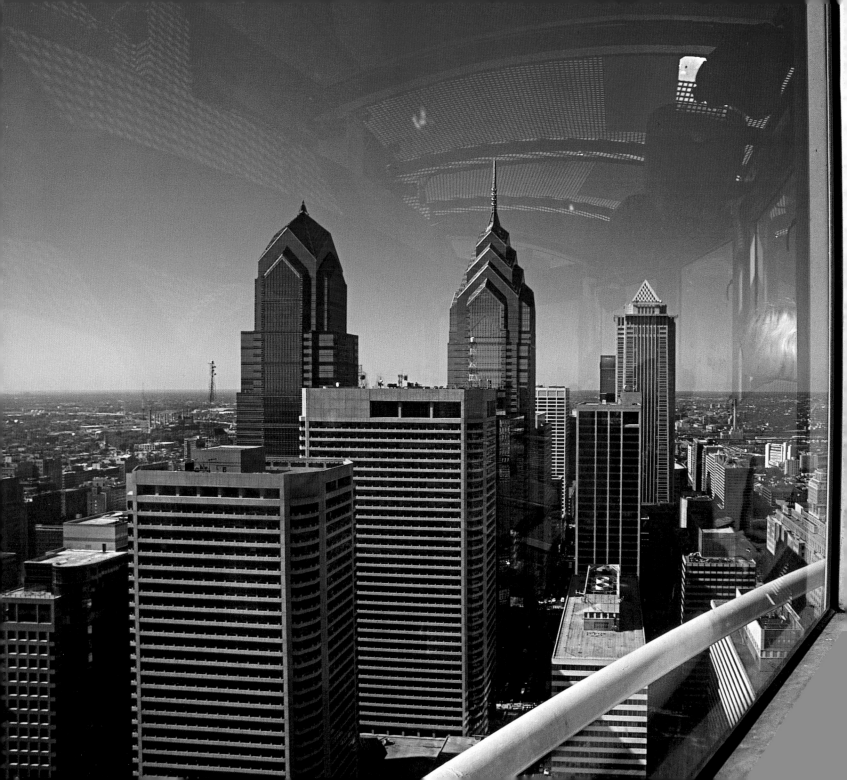

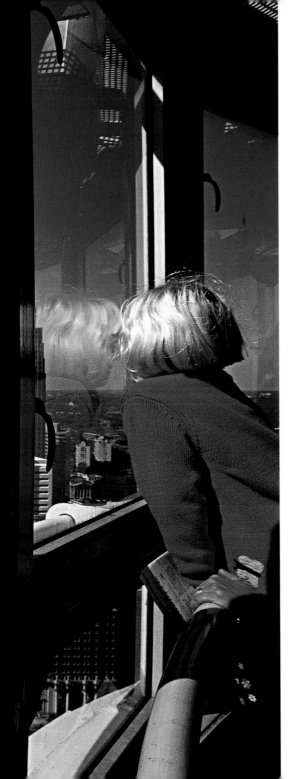

Left: Visitors to City Hall's observation deck view Philadelphia's financial district.

Below: The Melrose Diner in South Philadelphia grew from the original 1935 counter with nineteen stools. You can order breakfast any time—and don't forget the scrapple, that frugal colonial concoction of cornmeal mush that is mixed with pork offal and herbs, then sliced and fried.

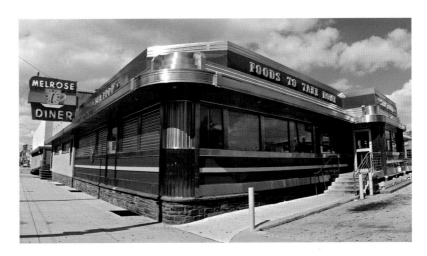

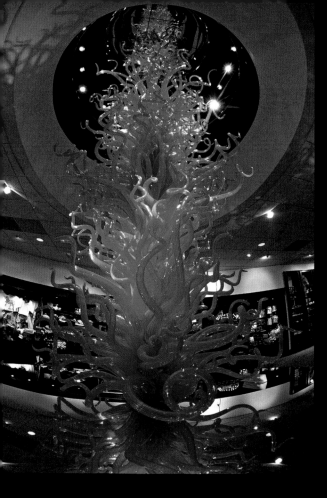

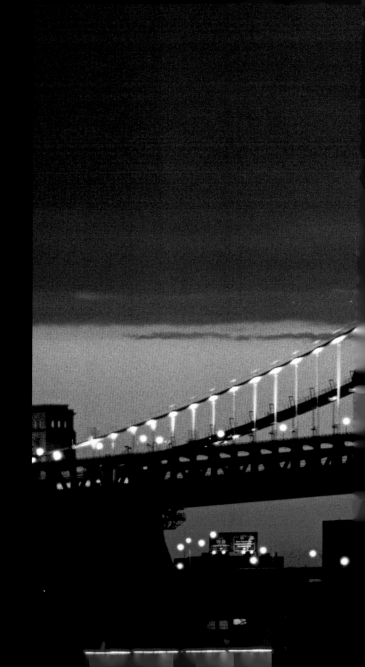

Above: In the educational National Liberty Museum, Dale Chihuly's twenty-foot-tall glass sculpture *Flame of Liberty* demonstrates that liberty is vibrant but fragile.

Right: When it opened in 1926, the Benjamin Franklin Bridge over the Delaware River was the largest suspension bridge in the world.

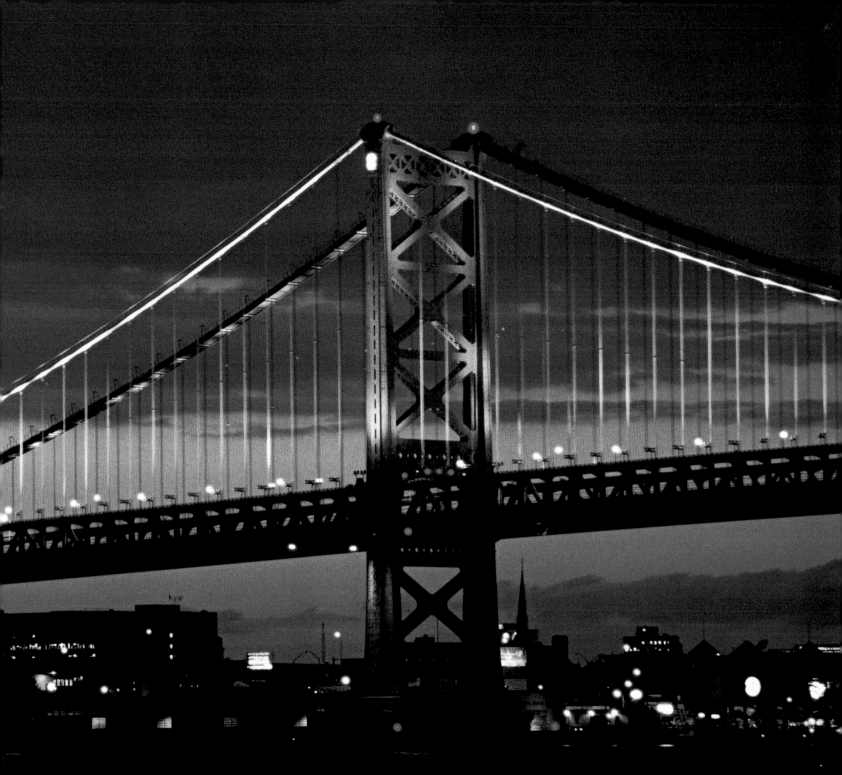

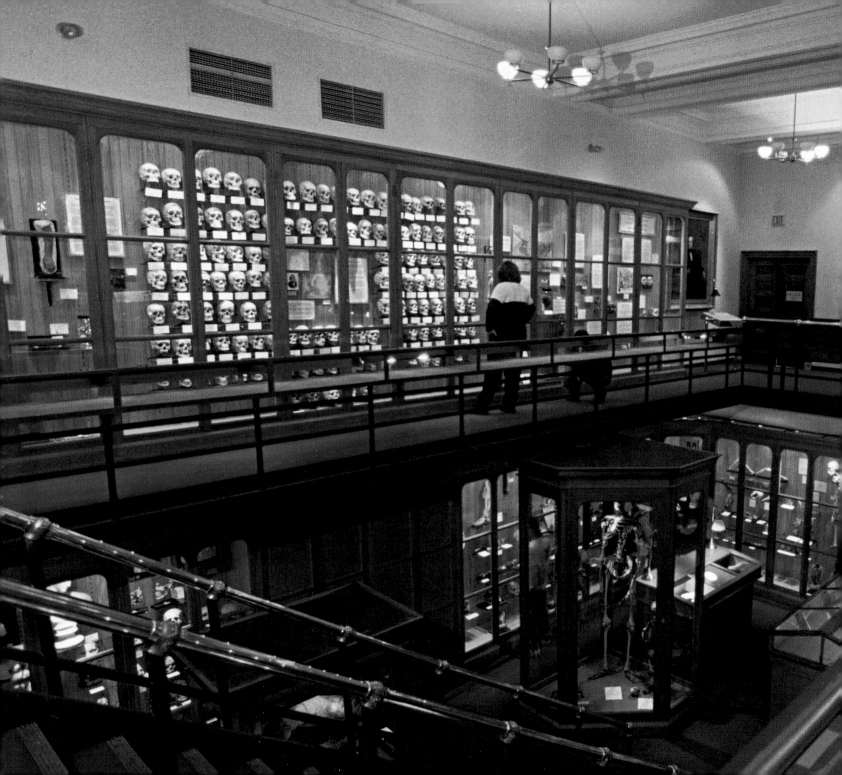

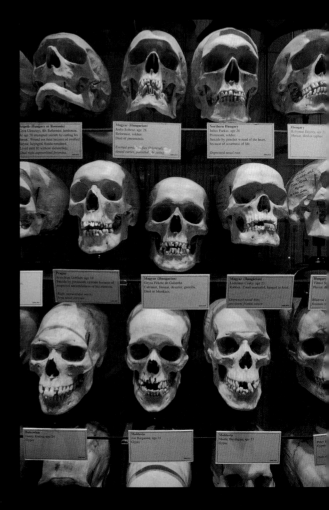

At the College of Physicians of Philadelphia, the Mütter Museum was created to show future doctors examples of human illnesses and malformations. Open to the public, the collection includes 20,000 preserved specimens (including skulls showing the ravages of syphilis) anatomical and pathological models, medical instruments, and memorabilia of famous physicians.

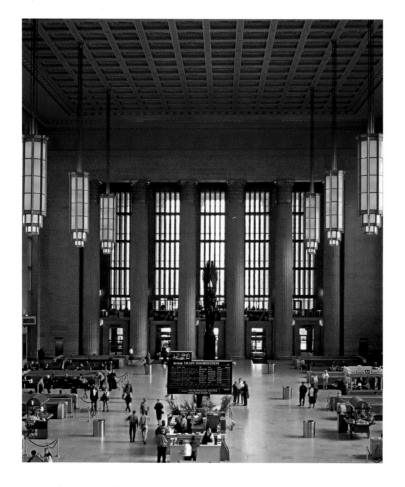

Above: The Thirtieth Street Station, built in 1934, today serves Amtrak and SEPTA (Southeastern Pennsylvania Transportation Authority) trains, and houses Amtrak corporate offices, restaurants, a parking garage, bank, and post office.

PHOTO BY BOB KRIST

Right: Independence Hall's exterior is a fine example of Georgian architecture's subdued, formal style. (During an 1828 restoration, the non-Georgian spire was added.) Pennies contributed by Philadelphia children beginning in 1860 funded the statue of George Washington, which was erected in 1869.

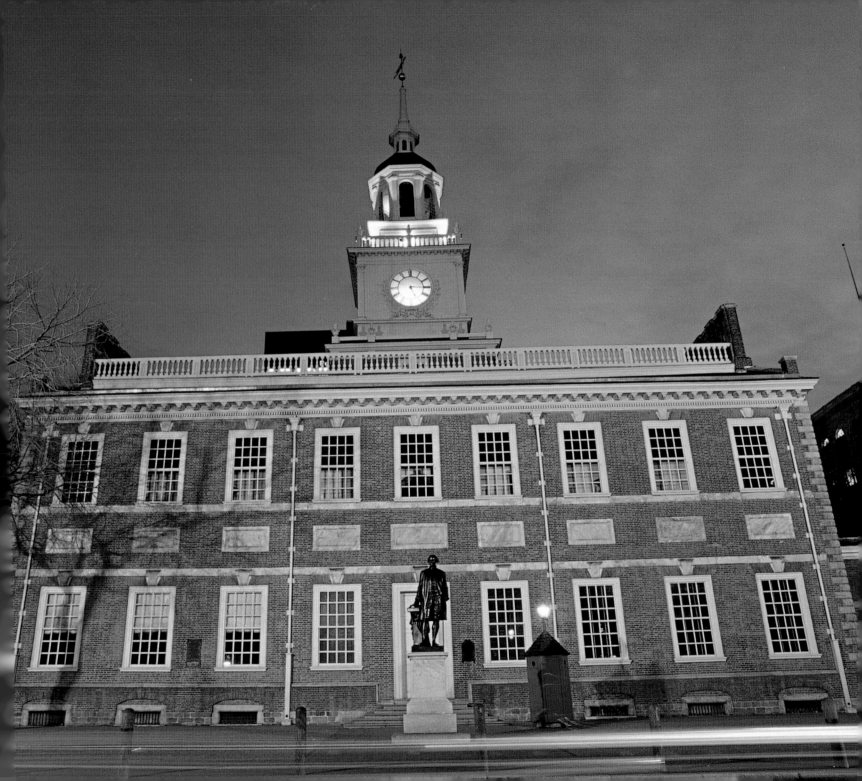

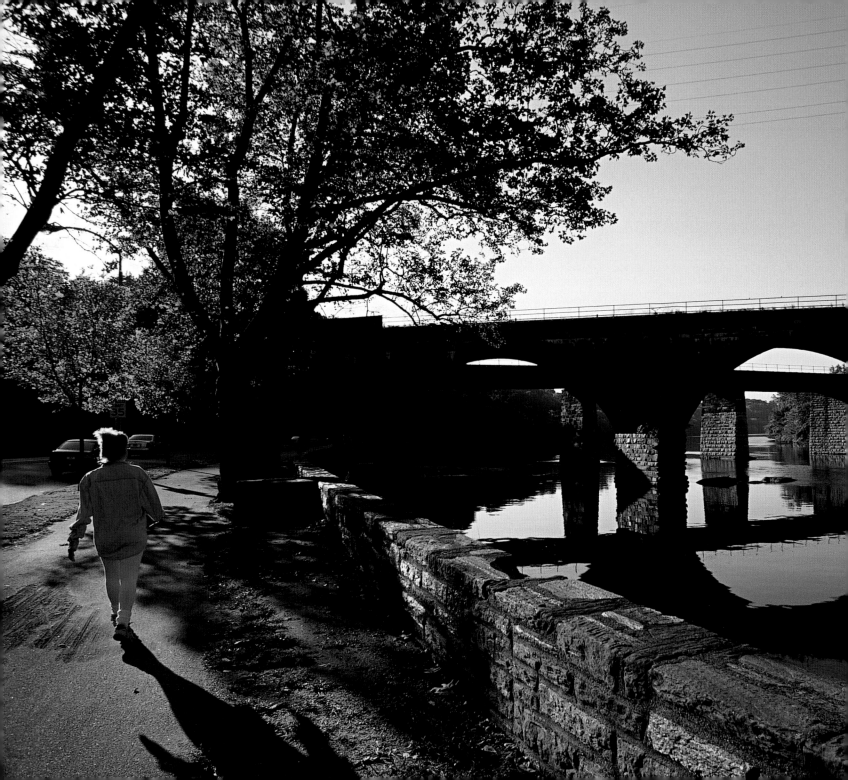

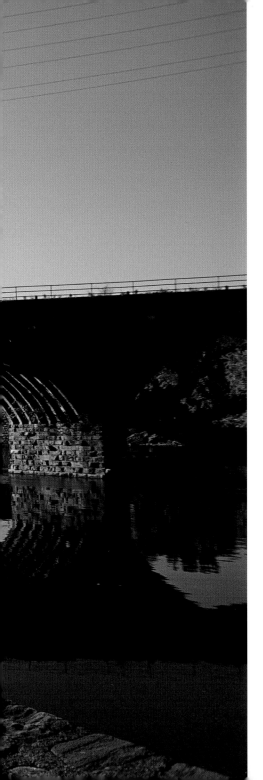

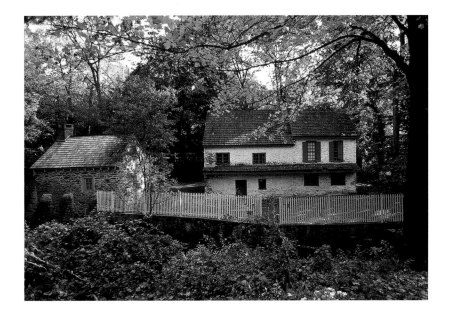

Above: Rittenhouse Town in Fairmount Park includes America's first paper mill, built in 1690 by William Rittenhausen, whose name was anglicized to Rittenhouse. The town features the homes of ten generations of the Rittenhouse family who have lived here and operated the mill for 150 years.

Left: Fairmount Park's railroad bridges were built by the Baltimore & Ohio Railroad and the Reading Railroad, which held rights-of-way through the park system.

Right: First Bank of the United States, the nation's oldest bank building, was built in 1795, its charter signed by George Washington. His Secretary of the Treasury, Alexander Hamilton, conceived of the bank to handle the nation's Revolutionary War debt and to standardize currency.

Far right: From its opening in the early 1800s, Fairmount Water Works on the Schuylkill River attracted tourists to marvel at the technology that supplied Philadelphia's water and retained a parklike setting.

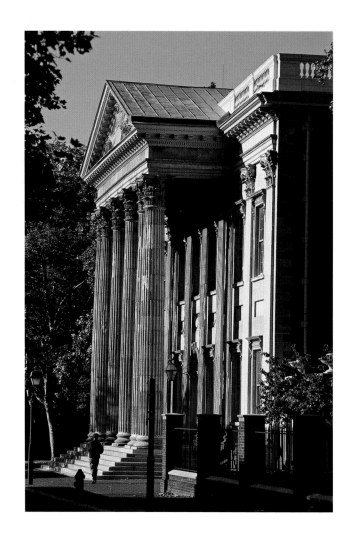

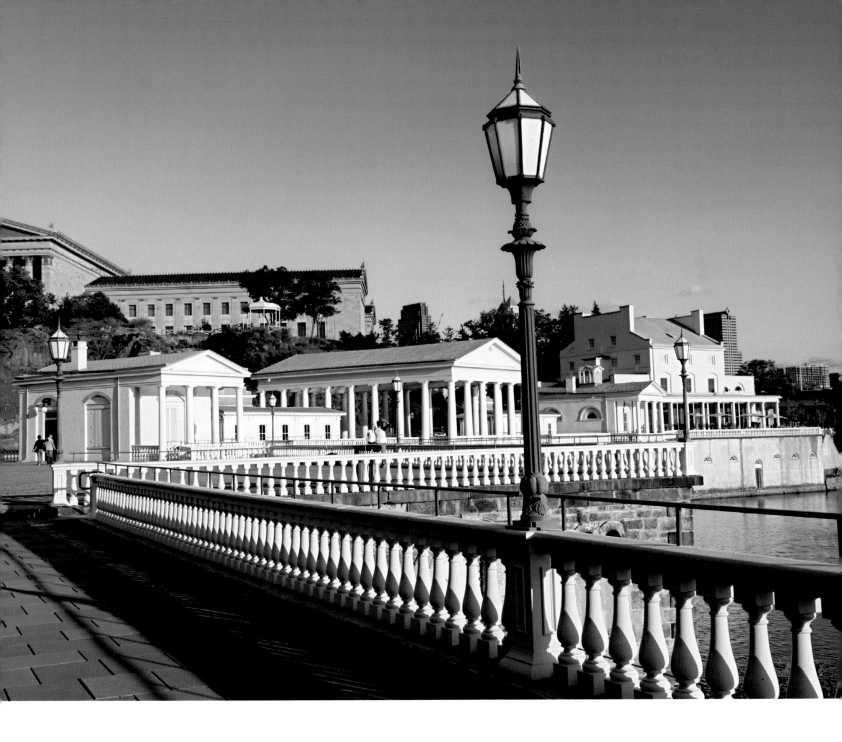

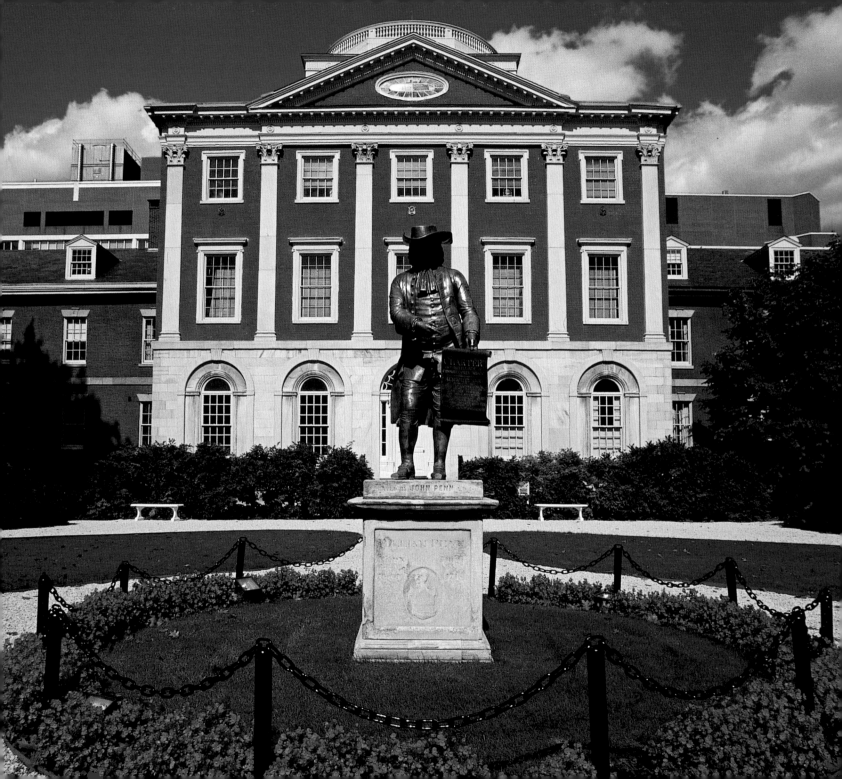

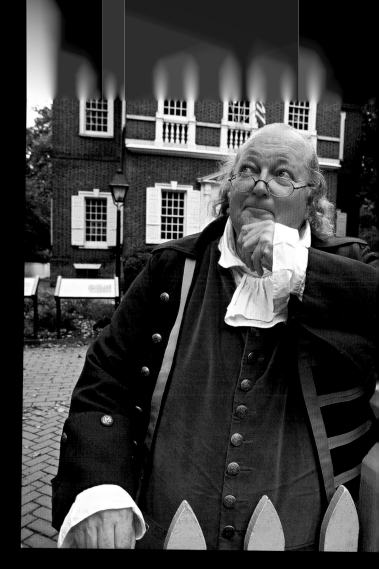

Above: A reenactor brings to life one of Philadelphia's favorite citizens, Benjamin Franklin—scientist, publisher, author, diplomat, and a Founding Father of the United States.

Left: Franklin and Dr. Thomas Bond founded the Pennsylvania Hospital in 1751, the colonies' first. Stories say that the spirit of William Penn leaves his statue and strolls the hospital's grounds.

e 1976, Claes Oldenburg's
-foot-tall sculpture *The
1* has added a quirky
he corner of Fifteenth
et streets.

Broad Street between Thir-
d Fifteenth streets is also
s Avenue of the Arts and it
the restored, early-twentieth-
Merriam Theater, where tour-
lway companies take the stage.

ges: The Philadelphia Museum
ourtyard glows at twilight.

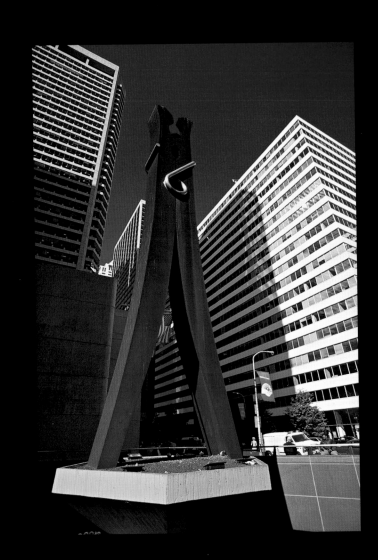

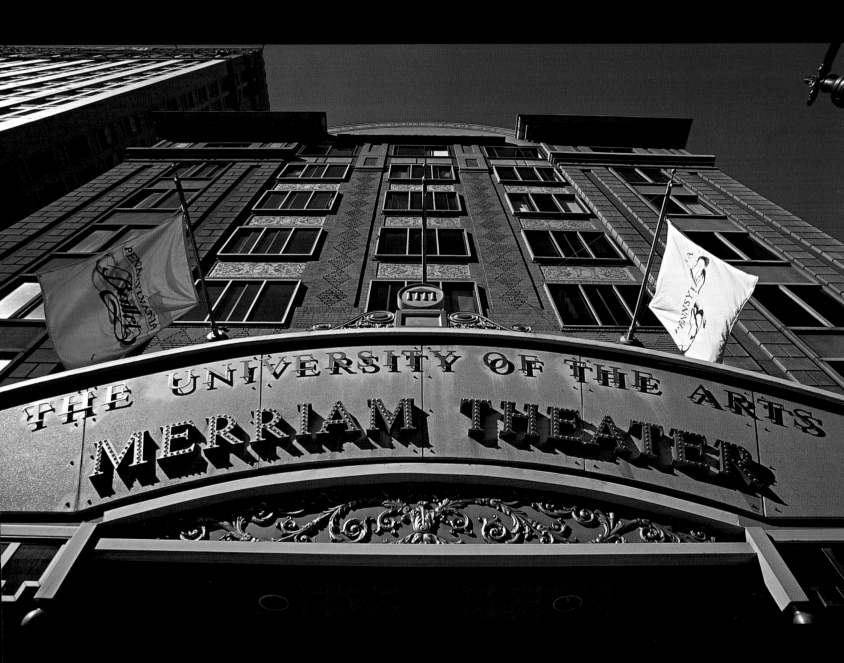

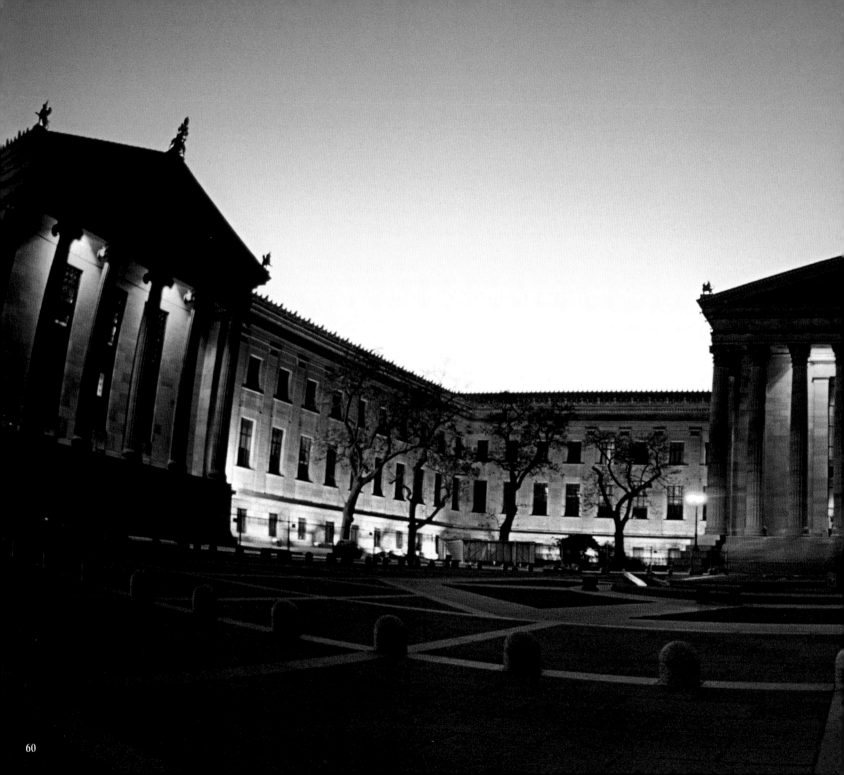

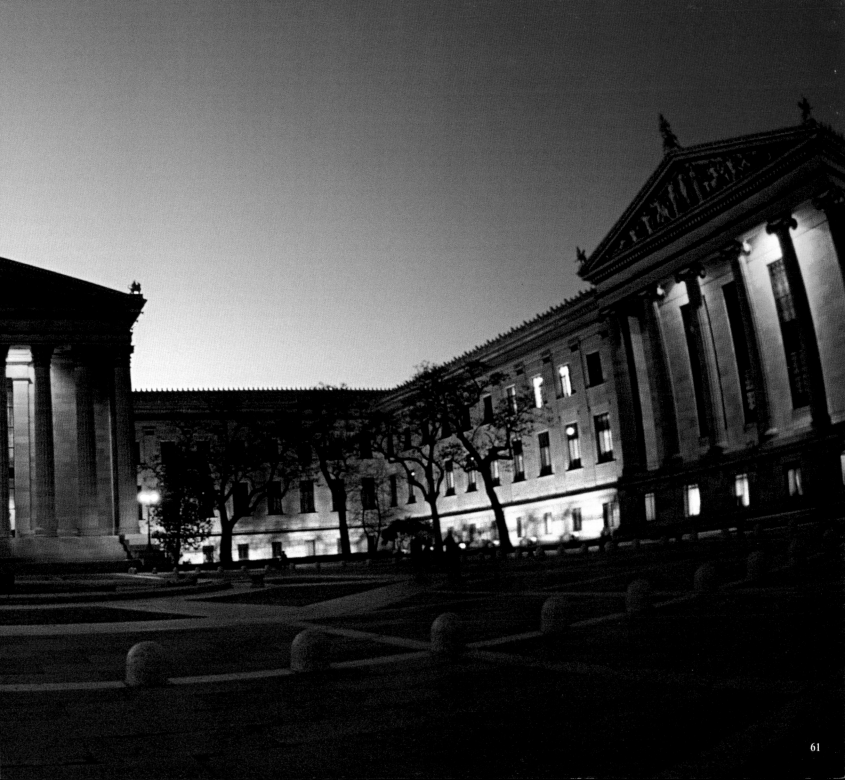

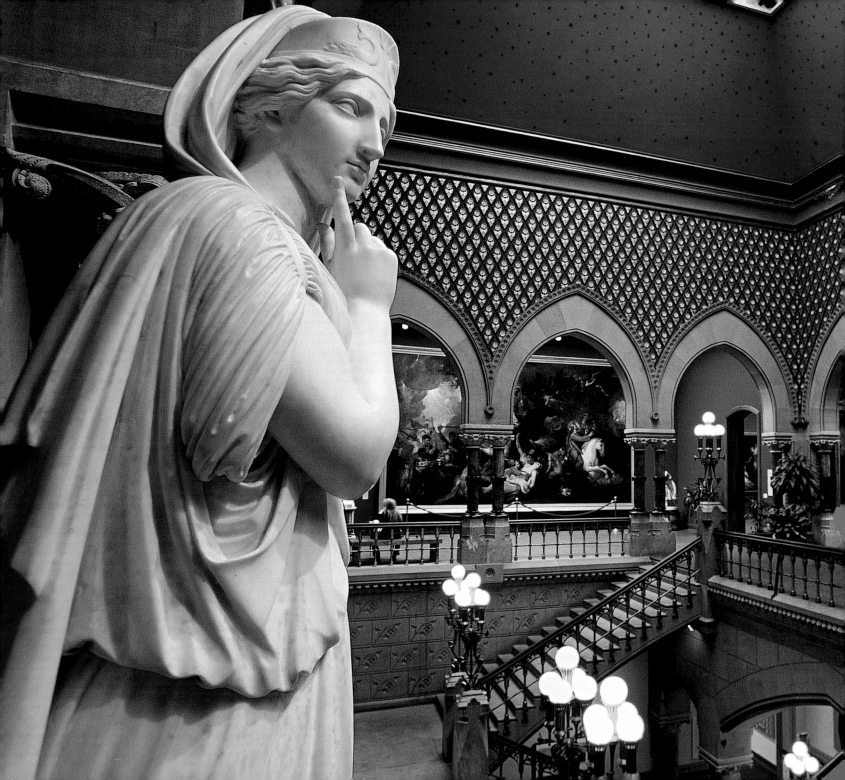

Above: Bright signs on an antique light post help guide Philadelphia's many tourists around Center City.

Left: A pensive classical sculpture seems to ponder one of the Philadelphia Museum of Art's 200 galleries.

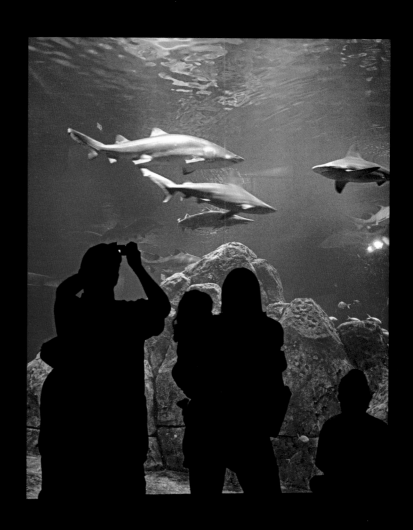

Right: Shark Realm attracts visitors to Adventure Aquarium in Camden, New Jersey—just east of Philadelphia across the Delaware River.

PHOTO BY ABRAHAM NOWITZ

Facing page: A pane of glass separates two curious creatures as they inspect each other at the Philadelphia Zoo.

PHOTO BY ABRAHAM NOWITZ

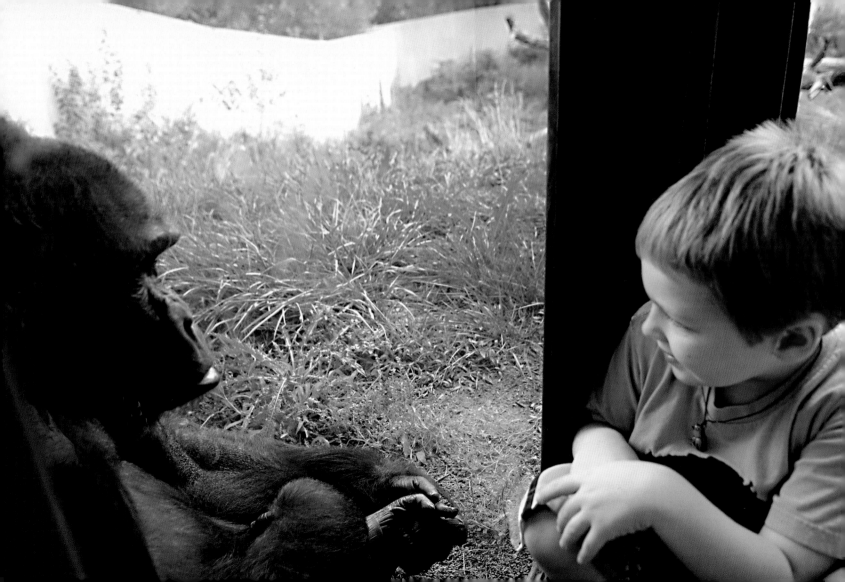

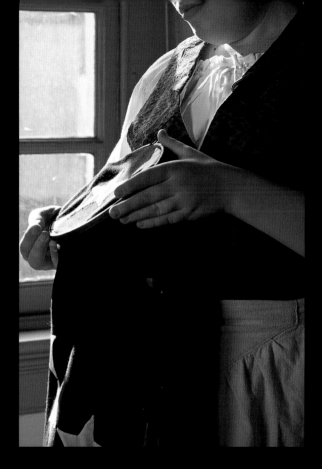

Above, left: Her family's oral history holds that, in 1777, George Washington took a sketch to upholsterer Betsy Ross and asked if she could produce a flag from it. He agreed to her suggestion to change the six-pointed stars to five-pointed ones, and she executed the commission.

Above, right: A reenactor portrays the legendary flag maker at Betsy Ross House, her home from 1773 to 1785 and a museum since Flag Day, June 14, 1937.

Facing page: Colonial architecture surrounds Head House Square, site of a marketplace in the Society Hill neighborhood

Above: The Philadelphia Walk of Fame on the Avenue of the Arts, Broad Street, honors musical performers of all genres and eras.

Right: When Eastern State Penitentiary opened in 1829, its wagon-wheel floor plan and single-occupancy cells represented a new, Quaker-inspired concept in penology: that prisoners could best be reformed by isolation. The prison closed in 1971 and today is a National Historic Landmark open for tours.

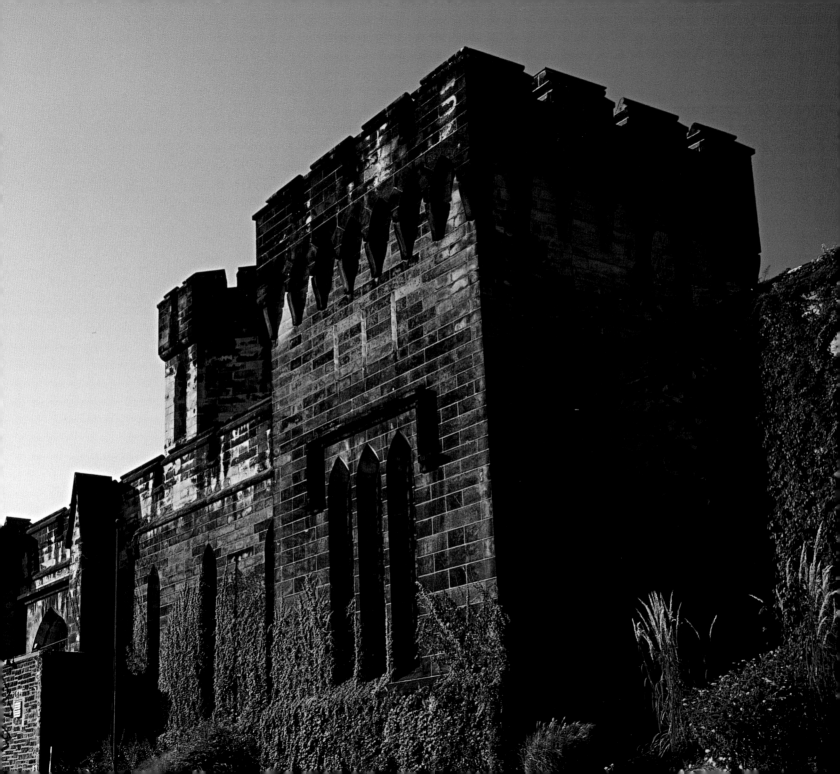

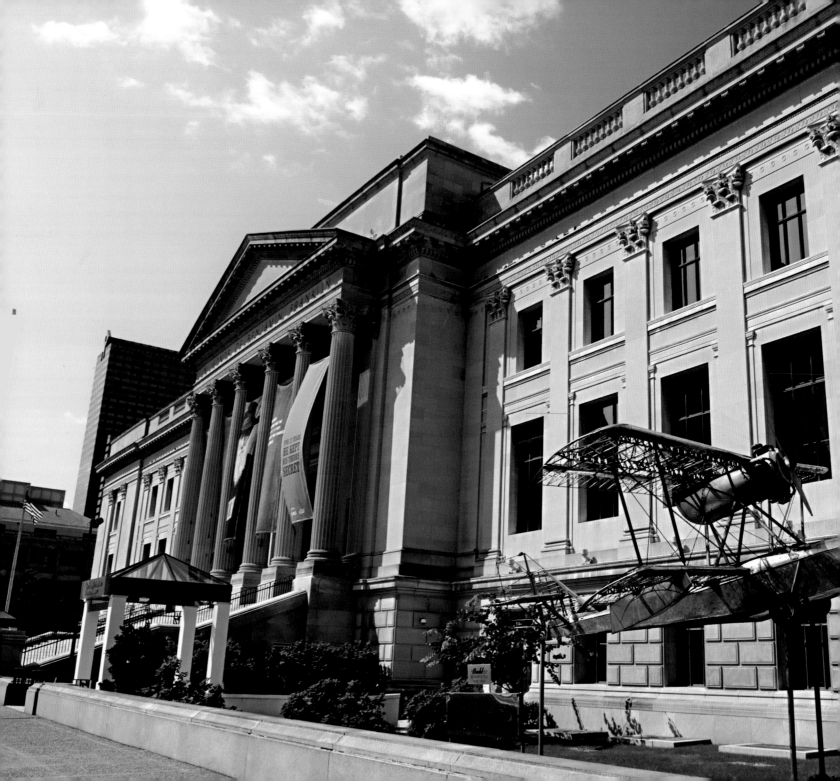

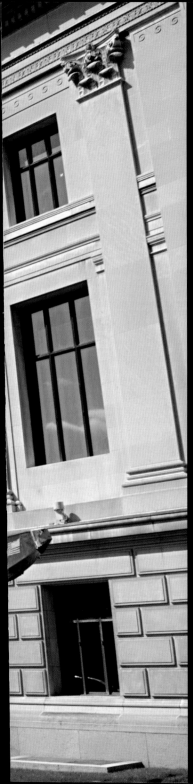

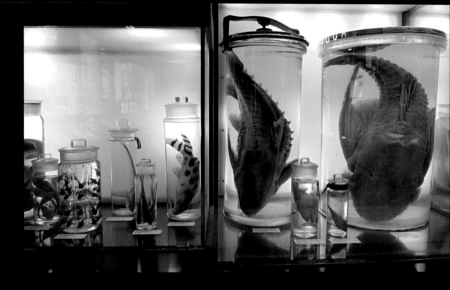

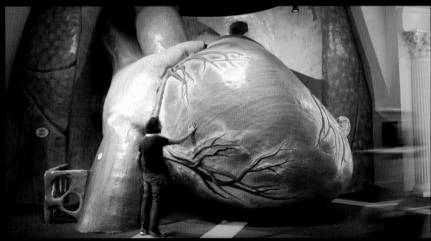

Above, top: The Academy of Natural Sciences, founded in 1812, is one of the world's premier science museums. The collection includes more than 17 million specimens, such as these ancient fish.
PHOTO BY ABRAHAM NOWITZ

Above, bottom: The hands-on Franklin Institute Science Museum includes exhibits such as The Giant Heart, a walk-through model large enough to power a 220-foot-tall human.
PHOTO BY ABRAHAM NOWITZ

Left: In front of the Franklin Institute since 1930, this stainless-steel amphibian aircraft has withstood all types of weather and continues to shine.
PHOTO BY ABRAHAM NOWITZ

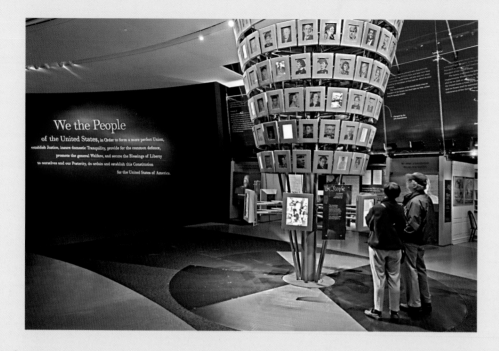

Above: On July 4, 2003, the National Constitution Center opened on Independence Mall to present and explain the United States Constitution through more than 100 interactive and multimedia exhibits and artifacts.

PHOTO BY BOB KRIST

Right: When Philadelphians say, "Billy Penn," they're referring affectionately to the bronze statue of city (and colony of Pennsylvania) founder William Penn, which stands atop City Hall, to the right in this view. At thirty-seven feet tall and twenty-seven tons, the Alexander Calder work is the largest building-top sculpture in the world.

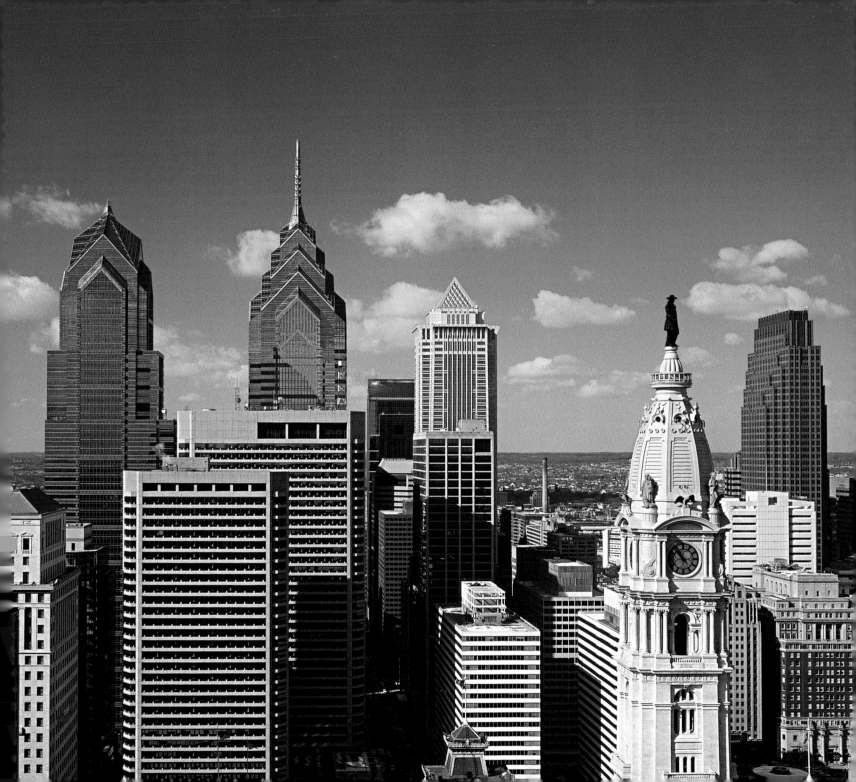

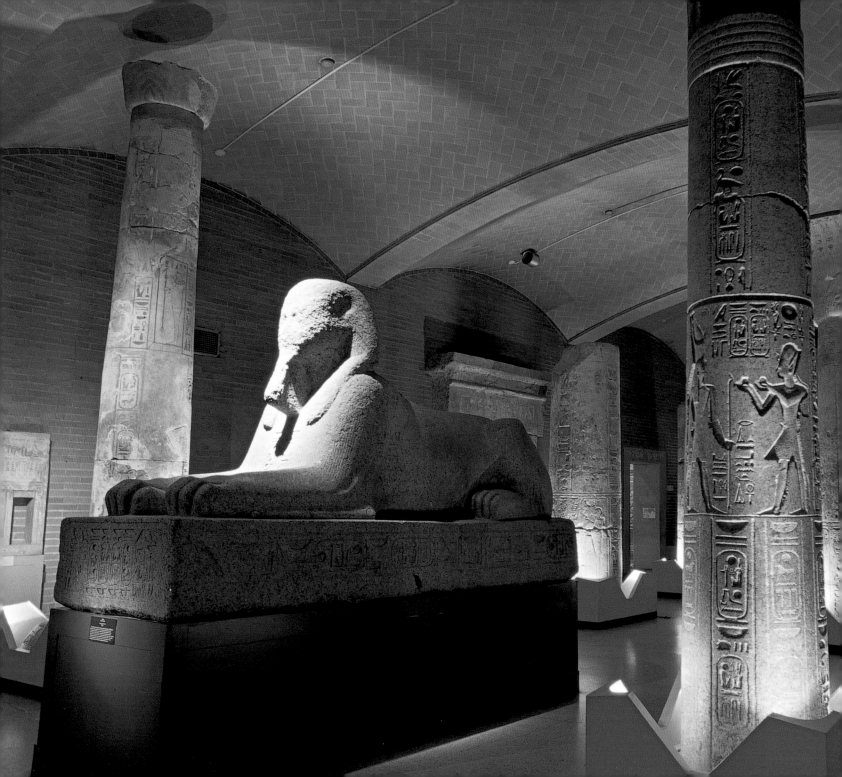

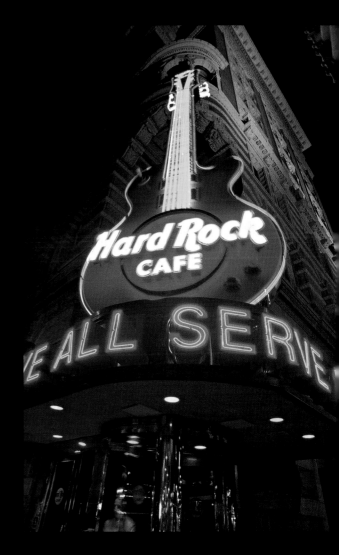

Above: Since 1998, a Hard Rock Cafe has occupied the corner of Twelfth and Market streets in Philadelphia.

Left: The Egyptian Galleries of University of Pennsylvania's Museum of Archaeology and Anthropology are just one of the museum's thirteen collections from cultures around the world. The museum itself dates from 1891.

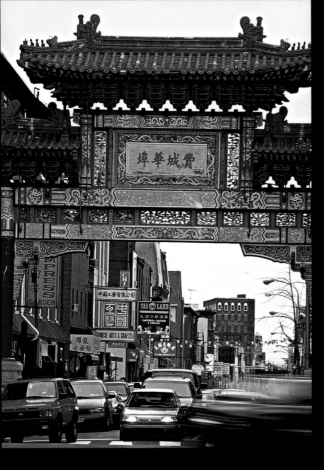

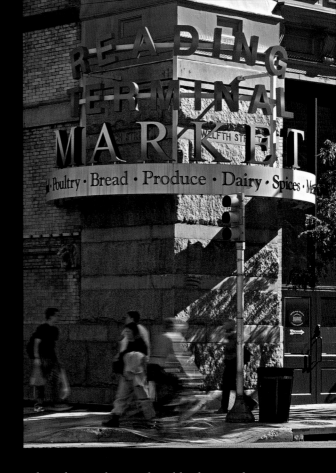

Designed by architect Sabrina Soong, the China Gate in Chinatown was constructed in 1984 by specialized workers from China, who used tiles from Philadelphia's sister city of Tianjin.

When the Reading Railroad built its eight-story terminal in the 1890s, it brought indoors the markets that had existed on the site since 1653. Today the railroad no longer exists, but some eighty merchants sell a wide variety of foods, ingredients, and other products here.

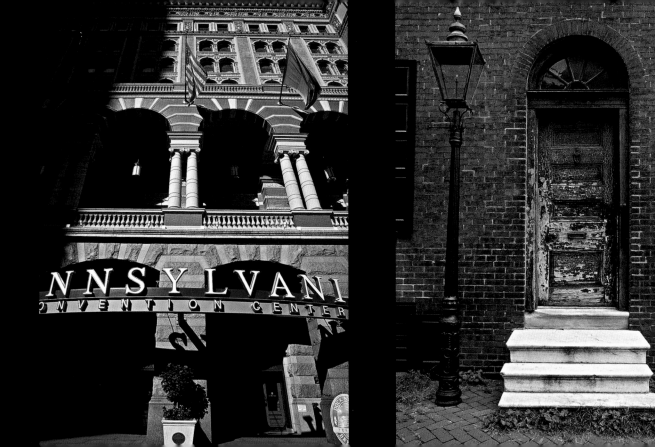

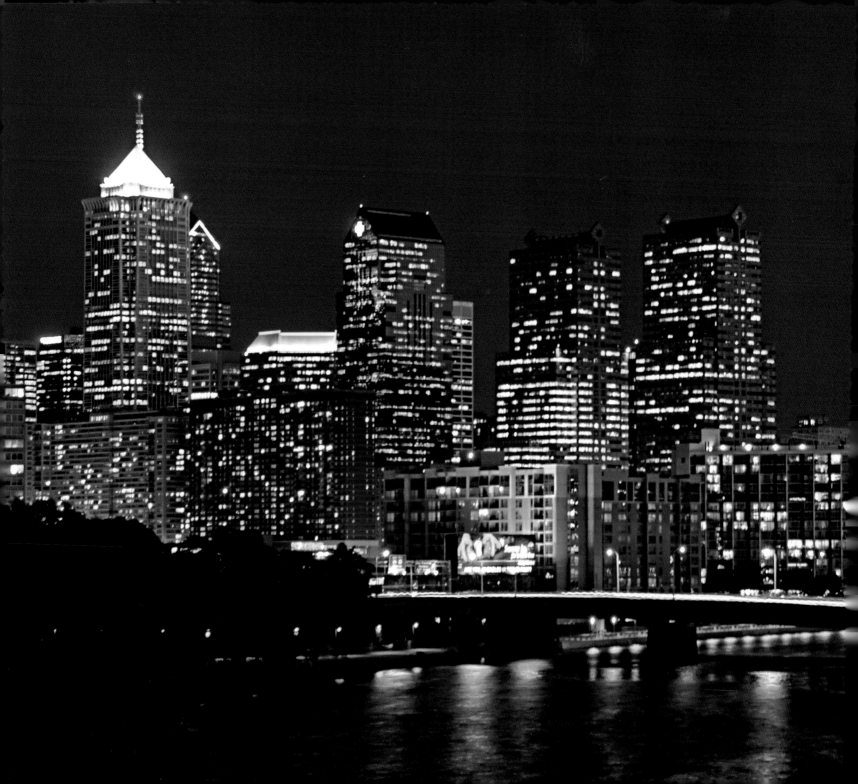

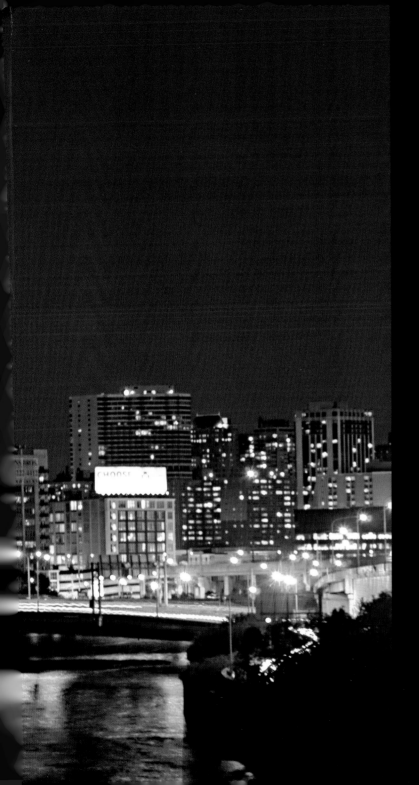

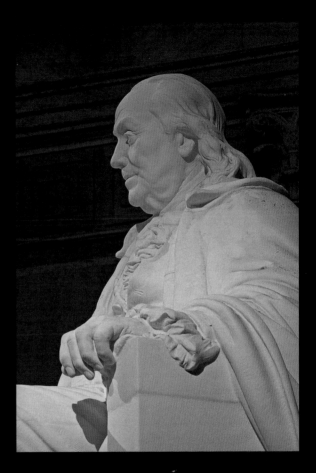

Above: In the Franklin Institute Museum of Science, a statue honors the institution's namesake.

Left: The night sky darkens over office buildings and the Schuylkill River.

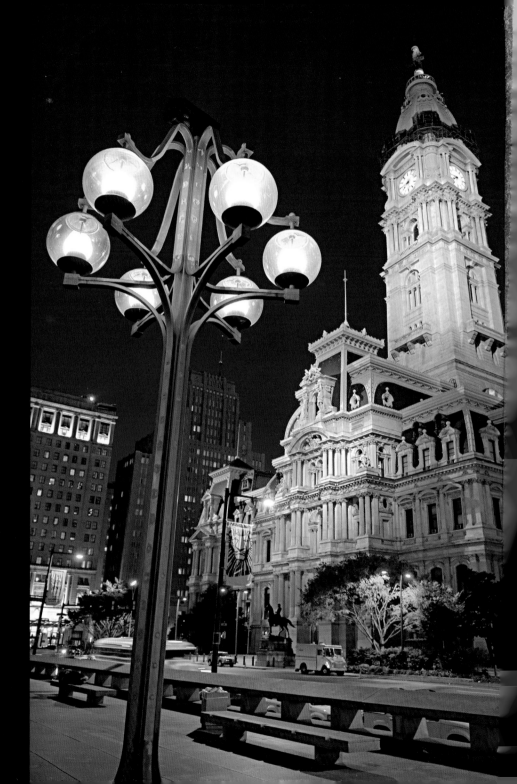

Richard Nowitz's photographs regularly appear in the world's leading travel guides and magazines. He has more than twenty-five large-format photo books to his credit. Richard Nowitz has been a contract photographer with National Geographic World, Traveler and Book Division. His photograph of camels at Giza was selected as the logo for the National Geographic TV News Channel. His photos are syndicated worldwide through the Corbis and National Geographic Image Collection, and his own award-winning web site is www.nowitz.com.

Right: Philadelphia City Hall, constructed from 1871 to 1901, rises 548 feet to the top of the William Penn statue.